PAINTING SHARP FOCUS STILL LIFES

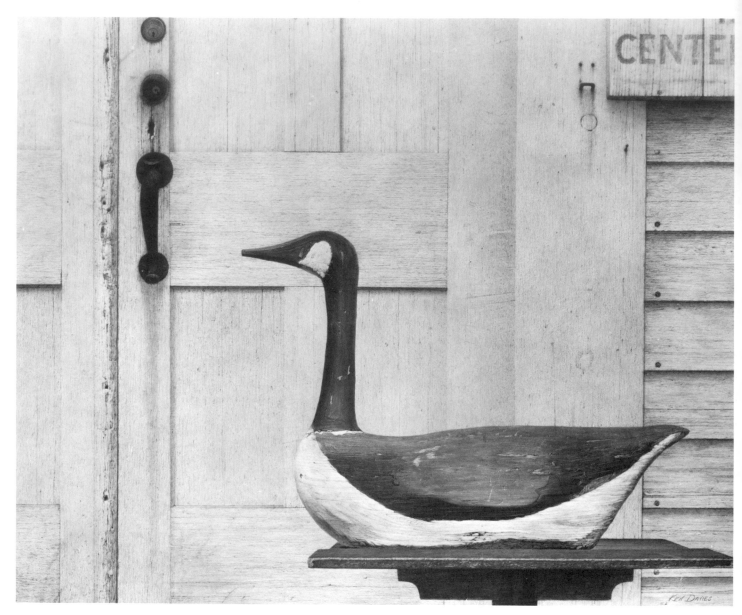

Antique Sale, Canadian Goose Decoy

PAINTING SHARP FOCUS STILL LIFES

TROMPE L'OEIL OIL TECHNIQUES

BY KEN DAVIES AND ELLYE BLOOM

WATSON-GUPTILL PUBLICATIONS/NEW YORK

PITMAN PUBLISHING/LONDON

First published 1975 in the United States and Canada by Watson-Guptill Publications
a division of Billboard Publications, Inc.
One Astor Plaza, New York, N.Y. 10036

Library of Congress Cataloging in Publication Data
Davies, Ken, 1926–
 Painting sharp focus still lifes.
 Includes index.
 1. Still-life painting—Technique. 2. Trompe l'oeil
painting. I. Bloom, Ellye, 1929– joint author.
II. Title.
ND1390.D35 1975 758'.4 75-20196
ISBN 0-8230-3856-4

Published in Great Britain by Sir Isaac Pitman & Sons Ltd.
39 Parker Street, London WC2B 5PB
ISBN 0-273-00091-8

Manufactured in U.S.A.

First Printing, 1975

To Fox and Norman

CONTENTS

ACKNOWLEDGMENTS

The authors wish to express their appreciation to Adele and Edward Paier for their patience and cooperation during the writing of This book; to Don Holden, who initially believed in our project; to our editor, Sarah Bodine, for the skill and diplomacy with which she coordinated the book's content and brought it to completion. Thanks also to Dan Becker, who masterfully processed all black and white photographic material.

INTRODUCTION

In this book I hope to provide logical, step-by-step information that will enable the reader to paint sharp focus realistic still life paintings. The information is intended for the serious student or the experienced painter who is willing to devote many hours of hard work to practicing the essentials. It is not for the hobbyist or the casual "Sunday painter." To avoid misunderstanding, please let me hasten to add that I intend no snobbery. It is simply a fact that sharp focus realism needs more time, practice, hard work, and endurance than the average hobbyist is probably willing or able to devote. The arduous steps involved can be tremendously exciting and rewarding to the student who is interested in sharp focus realism. To those who are not, it can be a colossal bore! I know this is true from my first-hand experience of 25 years spent in teaching. During this time I've watched art students react and respond (positively and negatively) to the same information that you're about to be faced with.

The first two parts of this book contain a detailed series of projects and exercises that I developed for the first- and second-year drawing and painting courses at the Paier School of Art in Hamden, Connecticut. These lessons are still being taught at the school. In fact, many of the illustrations included here have been done by Paier students who have followed this course. Both these parts are in-tended to provide the technical "know-how" needed to produce exhibit-worthy paintings. However, your total work output during this time should be regarded as strictly practice pieces—not finished paintings. Their only purpose is to teach how to see and record accurately *shapes, values,* and *colors*! If you persist and conscientiously develop the ability to accomplish those three very important things, I promise that eventually you'll have the ability to represent on canvas or panel a highly accurate reproduction of any object or group of objects you choose. My instructions will often seem dogmatic, and some of the time limits set for completing paintings might seem oppressively short, but bear with me. I know it works. Have faith, and remember, upon "graduation" from the last exercise *you* can make the rules.

The demonstrations in Part Three welcome the reader into my studio where I'll "think aloud" during the painting of four pictures. I'll try to describe in detail the how and why of the evolution of a painting by my own methods. I'll let you share some of the labor pains, too. In addition, in the portfolio of paintings that I have done over the years each reproduction is accompanied by some of my thoughts about it.

I hope that I've aroused your interest and your sense of challenge. If I've succeeded, let's get to work.

MATERIALS AND EQUIPMENT

During my 25 years of teaching and painting experience, I've naturally developed preferences for certain kinds of materials that I think give me the best performance. For the purposes of this book I've extracted a basic list, but you may want to add to it as you become more familiar with your own painting needs. With few exceptions, the supplies can be easily found in any art supply store.

In tallying up the cost of everything you'll need, with the exception of an easel, I can fairly well predict that your initial outlay will be around $100. I haven't included the cost of an easel simply because the prices vary as widely as their quality and sturdiness.

Don't feel that it's necessary to buy all the supplies in the beginning. The first two projects deal with line drawing and perspective, so if you wish you can postpone buying paints and brushes until the third project, on black and white oil painting.

DRAWING SUPPLIES

Keep the following supplies close by during the drawing projects. It saves time and frustration to know that something you may need is within easy reach.

Bond Pad. You'll find that the paper of the bond pad is smooth and will give you a precise pencil line as you draw on it, whereas a rough or textured paper would give a quality that's undesirable in precise still life painting. Further, the bond pad comes in convenient sizes (9" x 12", 11" x 14", 14" x 17"), which you can hold in your lap or on the table with equal ease.

Tracing Pad. Tracing paper (14" x 17") is both convenient and necessary, especially for drawing in correct perspective. The tracing pad does not need to be of the finest quality; a thin, inexpensive onionskin should do nicely.

White and Gray Charcoal Paper. Any kind of white and gray charcoal paper will do and can be bought either in the form of a pad or in separate sheets, usually 19" x 25".

Drafting Pencil. Through experience I have found that a mechanical drawing pencil is a great convenience. The leads are replaceable and can be retracted and ejected at will. The 2H, HB, and 2B leads are of varying degrees of hardness (the 2H being the hardest). They will produce a thin, pure line on the bond paper, especially when the point is sharpened on a sandpaper block.

Charcoal Pencils. In general for making line drawings on charcoal paper you'll need charcoal pencils 2B, 4B, and 6B. They are soft pencils that respond easily to the surface texture of the charcoal paper. The 2B pencil will be needed for shading light values. I'd like to stress the importance of keeping long, sharp points on all the pencils you use. If you let your pencil points get stubby, you'll end up with messy, smudged lines.

White Conté Pencil. As you'll see, the white Conté pencil is absolutely essential for shading procedures on gray charcoal paper. Again, keep the point long and sharp.

Sandpaper Block and Single-edged Razor Blade. With these two important tools you can keep your pencil points in great shape. Use the razor blade to sharpen the pencils to elongated points, and keep rubbing the tip of the point on the sandpaper block as you draw to keep the points very sharp.

Kneaded Eraser. Nobody's perfect; we all make mistakes in drawing no matter how careful we are. This soft, gummy type of eraser retain line can be kneaded into the shape you want and can be manipulated very easily to delete lines with a minimum of smudging.

Plumb Bob. You can fashion your own plumb bob from a large nut or bolt, a heavy fishing weight, or any other weighted object. Tie the weight to a piece of string 4 to 5 feet long. You'll need the plumb bob to lay out your drawing in proper perspective.

Small Carpenter's Level. When you use a 6" to 8" long level in conjunction with the plumb

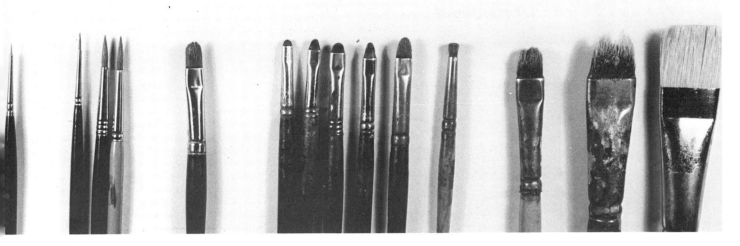

1. *Brushes (left to right): an 000 sable used for the smallest details; three round sables—a No. 1 and two No. 6, a filbert sable with rounded top used for painting larger areas than the pointed sable; five old, worn filberts used to soften edges and blend small glazed areas; an old round sable, cut down with a razor blade and then smoothed with fine sandpaper used for softening edges and "scumbling"; and three bristles—two old, worn ones used for scumbling large, coarse textures and a newer one for blocking in large areas.*

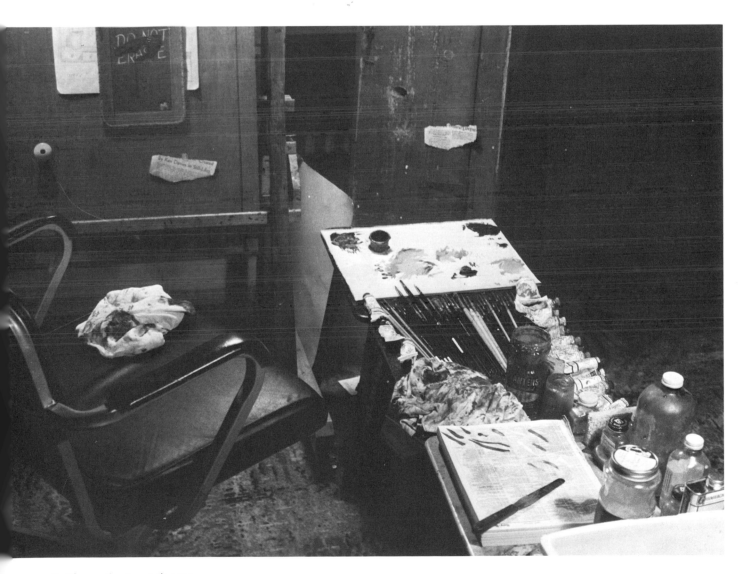

2. *The author's work area*

bob, you'll be able to line up vertical and horizontal checkpoints to sharpen the perspective of your drawings. You can buy the level at any hardware store.

Ruler. You're going to have to draw straight lines, and I believe that even the best-trained hand can have trouble accomplishing this without a ruler. I'd say that the most convenient length for a ruler is about 18".

Fixative. Buy a large economy-size can of spray fixative. It will keep charcoal pencil lines from smudging, which will be a definite benefit in both the drawing and painting exercises.

PAINTS AND BRUSHES

My own preferences in oil colors are listed below. Even though the group is limited, I feel it makes up an adequate palette. Please bear in mind, however, that this is only a *suggested* group of colors for those just breaking into the oil medium. As your painting experience grows, you'll surely want to add, or perhaps subtract, colors and experiment with new pigments on the market.

Each time a project or exercise requires a palette with a full range of colors, use all of the ones listed here:

Titanium white	Yellow ochre
Ivory black	Cadmium red light
Cobalt blue	Cadmium vermilion
Ultramarine blue	Cadmium red deep
Cerulean blue	Alizarin crimson
Viridian green	Burnt umber
Permanent green light	Burnt sienna
Sap green	Raw umber
Cadmium yellow light	Raw sienna

Sable Brushes. Personal preference applies to the choice of brushes as well as paints. (Figure 1.) Although sable brushes are very expensive (they will probably be one of your largest expenditures), they are essential in the type of oil painting with which this book deals. In spite of their delicate appearance, they're surprisingly durable. As they wear down, which of course they will, they can be trimmed to new shapes.

Sables come in round and flat shapes plus a variation of the two. For my course I recommend round, flat, and filbert types. The hairs of round sables are fitted into round metal ferrules and taper to a fine point. Flat sables are either short, in which case they are called "brights," or long. In either case they are flattened to a chisel edge. Filberts are a cross between the two. They are flat yet taper to rounded tips. As you become familiar with them, you'll discover that each has its own "personality" and its own kind of stroke. The different sizes of brushes are indicated by numbers. I recommend you start out by getting the following brushes:

Round: Nos. 3, 6, and 10

Flat: Nos. 4, 8, and 12

Filbert: Nos. 4, 8, and 12

Bristle Brushes. Bristle brushes produce textural effects that are quite different from the smooth strokes you can get with sables. Like sables, bristles come in flat, round, and filbert shapes. I suggest you start with the following:

Round: Nos. 2, 4, and 8

Flat: Nos. 4, 8, and 12

Filbert: Nos. 2, 4, and 8

How to Clean Brushes. Fill a large glass jar almost to the top with turpentine. Dip the brush in the turpentine, and wipe the excess paint off on the pages of the old telephone book. Wipe the brush with a paint rag to remove all remaining paint from the brush. Then dip the brush into the turpentine again and work the bristles up against the inside of the jar. When the brush is finally clean, wipe it again with a fresh rag. I find this method not only saves rags but prevents the turpentine from becoming dirty right away. Most painters finish the cleaning by washing the brush with ivory soap and lukewarm water.

OTHER PAINTING SUPPLIES AND EQUIPMENT

All the supplies that you'll need in the drawing and painting assignments should be placed on a table or taboret (a small portable table available at any art or office supply store) and kept close to your working area. It's a great convenience not to have to go hunting for some small item when you're in the

middle of a difficult passage. (Figure 2.)

Mediums. Oil paint as it's squeezed straight from the tube has a lustrous appearance, but for most painters its consistency is too sticky to work with. Just a few drops of a medium, such as a mixture of linseed oil and damar varnish, added to the paint will give it a buttery texture and enable you to move it around easily on the canvas. Most painters feel that painting in oils without a medium is like roller skating without ball bearings in the wheels.

Good-quality turpentine is another extremely useful medium. Add just a small amount to the linseed oil/damar varnish mixture to thin your paint for making washes. Because turpentine is a solvent, you can also use it for cleaning brushes and removing paint from your skin and clothing. (Be sure to wash your hands after removing paint from them with turpentine.)

My own favorite medium is a mixture of ⅔ linseed oil and ⅓ damar varnish, but you're welcome to experiment with others whenever you feel ready.

Paint Rags. Don't shortchange yourself on rags. It's a pleasant luxury to have plenty of them around when you're in a hurry to clean your brushes and do a general mop-up after a particularly messy painting session. My favorite rag is an old cotton tee shirt.

Telephone Book. Rather than using just rags to clean my brushes I use the pages of an outdated telephone book. I wipe the dirty brush on the paper, tear out the soiled pages and throw them away.

Palette and Palette Knife. Your art supply store can sell you a white paper palette that's shaped like the traditional wooden one but with an updated feature that I find very convenient: when you're through painting for the day, you can simply rip off and throw away the top leaf of the paper palette. The surface underneath it, of course, will be clean and ready for the next painting session.

Another reason that I like paper palettes is that I prefer mixing my paints on a very white background. That way, I can see exactly what color I'm getting for painting on a white canvas or board.

A strong, flexible palette knife is essential for scraping off unwanted paint strokes and for mixing colors.

Metal Cups and Other Containers. Quantities of linseed oil and turpentine should be kept close at hand at all times. The twin metal cups sold in art supply stores are just the right depth for dipping brushes into, and they conveniently clip onto your palette. I like to use these little metal cups to hold linseed oil and damar varnish. Since I use much more turpentine than any other liquid, I keep a medium-sized jar filled with it by my side.

Varnishes. While your painting is still wet it has a lively, glossy finish, but as the painting dries, parts of it may become flat or dull in appearance, certainly a discouraging development. Retouch varnish sprayed or brushed onto the surface will revive the luster. But remember that the retouch varnish must be allowed to dry before you continue to paint over it.

Semi-matte varnish, a mixture of damar and matte varnishes, is applied only after the completed painting is thoroughly dry. It will give the painted surface a moderate luster rather than a slick shine. I prefer to apply it with a 2″ varnishing brush. The surface should be completely free from dust before varnish is applied.

Painting Surfaces. Because their surfaces are rigid I prefer canvas board and Masonite panel to stretched canvas. The tension of stretched canvas can vary, while canvas board and Masonite are predictably firm. An incident which involved my son sold me finally on rigid surfaces. At the age of two, he decided to practice with one of my golf clubs and swung a 3-iron into one of my first major paintings, *Lighthouse In the Alps*. The result was a sizable hole in the lower center of the painting. It has been repaired, but the experience left me with a staggering aversion to anything less sturdy than canvas board or Masonite.

Color Wheel. Purchase a basic color wheel at your art supply store. Unless you are totally familiar with the color wheel, you should have one for reference while mixing colors.

Mahlstick. Sharp focus still life painting is ex-

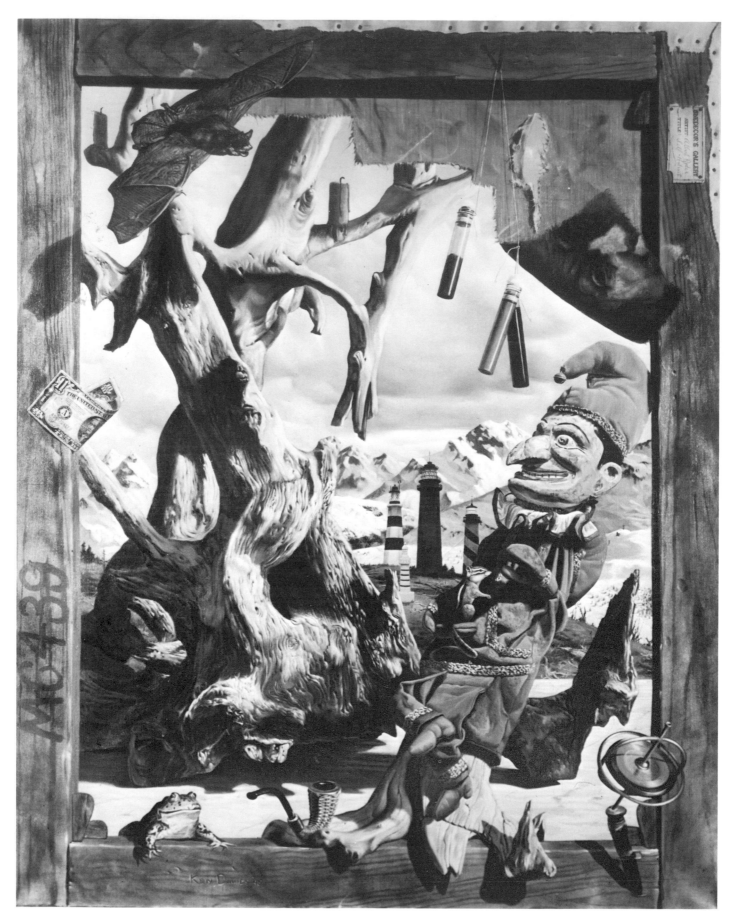

Lighthouse in the Alps

tremely precise and requires a steady hand. I use a mahlstick to give me the support needed to keep my wrist steady. If my wrist is steady I can keep my hand and brush in almost perfect control. You can make your own mahlstick by tapering an end of a 6-foot length of 1x2 lumber. To use it properly, stand one end on the floor and lean the other end across the painting, but not touching it, allowing it to rest against the easel. (Figure 3.)

LIGHTING

Lighting is an essential part of your work setup. It can alter the way your subject appears as well as the color of the pigments on your palette and work surface.

Natural Light. Because it varies tremendously, I prefer not to work under traditional north light. On sunny days, north light is blue. But even on cloudy or dull days when the light is neutral and therefore desirable, it changes intensity during the passing of the day. I use a neutral fluorescent bulb in my work area because its constant illumination is the most stable and reliable source, and I light my still life setups with a warm incandescent bulb.

Artificial Light. When you start to paint with oils, the color of the light you use will affect the tones you mix on your palette. An ordinary incandescent bulb is quite yellowish, while some of the fluorescent tubes cast a cold or even blue light on a subject. A good way to observe the effect of fluorescent versus incandescent light is by taking a walk through city streets at night. Look at the windows of office buildings and apartment houses and try to distinguish the windows that are lit with incandescent light from ones lit with fluorescent light. Notice the difference in their color. The difference in the warmth and coolness of the tones is quite spectacular.

If you paint under a yellow incandescent light, there will be a tendency to add too little yellow or warm color to the pigment. That's because the light tinges the color of the pigment with a degree of yellow. To eliminate this problem, use a neutral fluorescent bulb.

3. *The mahlstick is anchored with the fifth finger of the left hand against the easel while the right hand is steadied by resting on it.*

The spot in which the finished painting will be displayed has a direct relationship to the light under which it's painted. In art galleries, the lighting is generally on the warm side, whereas in commercial establishments cold fluorescent light is more often used. Although you can't really predict where your painting will be shown, I believe the use of a neutral fluorescent light will give you a good middle-of-the-road choice.

When I began to work commercially, I painted under yellow light. The paintings looked fine in the studio, but when I delivered them to a New York City advertising agency and displayed them under their cold fluorescent light, I was appalled by the change the color underwent.

In the projects and exercises that follow, I recommend using an incandescent bulb on the still life setup because it gives a more direct pinpointed source of light than a long fluorescent tube. These bulbs are inexpensive and certainly satisfactory for practice paintings.

A LESSON IN PERSPECTIVE

The subject of perspective deserves an entire book in itself, and there are, of course, many books devoted to this area. I urge every student of art to acquire one or two of them in order to become thoroughly familiar with this fascinating aspect of drawing and painting.

I won't go deeply into the study of perspective here, nor is it necessary if you limit yourself to still life painting, as you will see later, but I do want to talk about a few rules and facts that I feel are indispensable in their application to sharp focus still lifes. If you understand and memorize these facts, drawing and painting in correct perspective will become much simpler.

THE LINE IN PERSPECTIVE

The first consideration in a study of perspective is what happens to the simple line which is used to draw the objects in your setup.

Rule 1. *All receding parallel lines vanish at the same point.* Perhaps the simplest and most easily understood illustration of this rule is the classic one of the railroad tracks converging at a single point on the horizon.

Rule 2. *All receding horizontal lines have their vanishing points on the horizon line.* The horizon line, which will be referred to in the illustrations as H.L., represents your eye level. When you're in a sitting position, your eye level is naturally lower than when you're standing.

The key word here is *horizontal*, and by that I mean any receding line that is level with or parallel to the ground. Every straight line in your still life setup will be either horizontal, vertical, or inclining at an angle. Rule 2 applies only to the receding horizonal lines. Figure 1A shows three rectangular blocks on a tabletop. Notice that the receding lines on all three blocks and the receding lines of the two sides of the table converge at the same vanishing point. Although the block at the far left extends above your eye level (or horizon line), the top edges still converge at the van-

ishing point. This is a simple illustration of *one-point perspective.*

Figure 1B shows the same setup in *plan view*, or looking straight down from above. The front and back edges of the table and the three boxes are all at right angles to each other. In other words, they are perpendicular to the line of sight. This fact alone determines the use of one-point perspective.

The plan view in Figure 2A shows the same three boxes. The boxes at far left and far right have been moved. Figure 2B is a perspective drawing of the three boxes. The boxes at the far left and far right are at different angles, and now each has two vanishing points. The perspective drawing required the use of *two-point perspective.* Use two-point perspective when an object is not at right angles to the viewer's line of sight. The center box in Figure 2B and the tabletop remain in one-point perspective.

Rule 3. *All inclined lines have their vanishing points either above or below the horizon line.* Figure 3 shows a drawing of a piece of folded paper with half resting horizontally on the table and half raised above it. The parallel sides of the raised half of the paper (*ac* and *bd*) are at an angle and vanish at a point above the horizon and directly above the vanishing point of the lower half (*ce* and *df*). The upper edge of the raised half (*ab*) vanishes at the same point on the horizon line as its corresponding edges resting on the table (*ef*). Being parallel to the ground *ab, ef,* and *cd* vanish at the same point.

For our purposes, all the vertical lines in your setup will remain vertical in your drawing. This statement doesn't apply in three-point perspective, but the still life and trompe l'oeil painter rarely finds it necessary to use three-point perspective. If you thoroughly understand these few simple rules and diagrams, no straight line in your still life setup will be a mystery to you. If you accurately plot your still life drawings with the horizontal and vertical check points using the plumb bob and carpenter's level (see Project 1), you

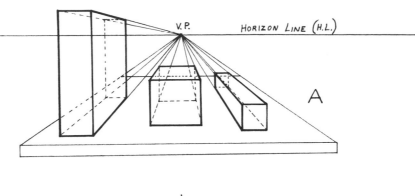

V.P.

HORIZON LINE (H.L.)

A

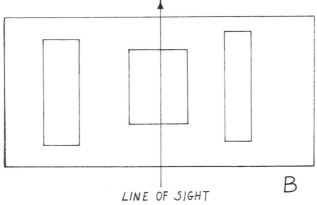

LINE OF SIGHT

B

1. *One-point perspective*

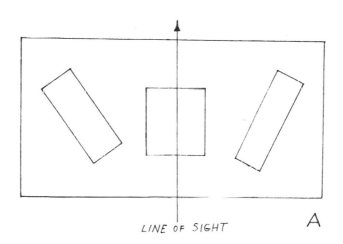

LINE OF SIGHT

A

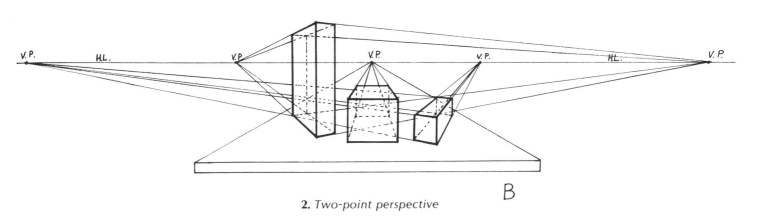

V.P. H.L. V.P. V.P. V.P. H.L. V.P.

B

2. *Two-point perspective*

17

don't actually need to know anything about perspective!

Of course, when you're ready to paint serious finished pictures for exhibition, you won't be restricted to copying your setup exactly as it is. You may want to enlarge or reduce an object or even change or exaggerate its shape. Your knowledge of perspective will then become a valuable, practical tool.

THE CIRCLE IN PERSPECTIVE

Another important subject in this extremely simplified discourse is the circle in perspective. A circle tilted into perspective becomes an ellipse. The closer a circle is tilted toward the horizon line the narrower it becomes. When it is tilted to coincide with the horizon line it's no longer an ellipse but a straight line (Figure 4). The narrower the ellipse, the easier it is to draw. You'll discover this when you start to draw ellipses in Project 1.

A geometric ellipse (Figure 5A) has a major axis (a–b) and a minor axis (c–d). The intersection of these two axes is the geometric center of the geometric ellipse. But the geometric center is *not* the center of the perspective circle. Even though the outline shape of a geometric ellipse is used for a perspective circle, the center of the two figures is not the same. A circle fits into a square, a geometric ellipse fits into a rectangle, and a perspective circle fits into a perspective square (Figure 5B and 5C). In the perspective circle (5C) the distance from the front to the center is greater than the distance from the center to the back. But notice that in the geometric ellipse (5A) the center is equidistant from the front to the back. Dot *a* is the center of the perspective circle, and dot *b* is the center of the geometric ellipse. Keep these facts in mind whenever you need to indicate the center of a circle in a drawing.

Here's one more important bit of information that will help you to draw the circle in perspective: When a circular object such as a cylinder or bottle is absolutely vertical, the major axis of its ellipse is always horizontal and the minor axis is always vertical. But if the object is tilted at any angle or is resting on its side, the situation changes.

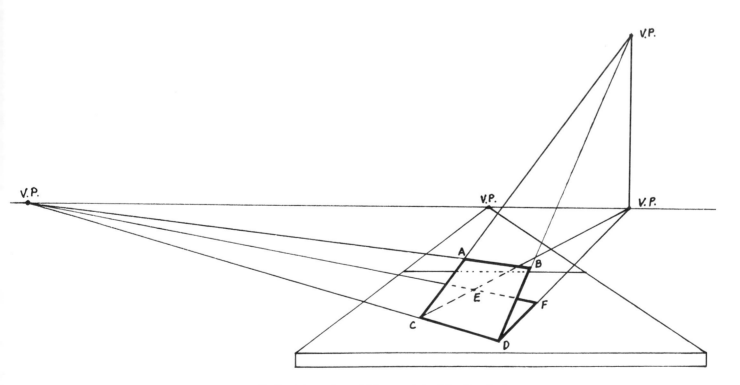

3. *Position of vanishing point of inclined plane shown directly above ground vanishing point.*

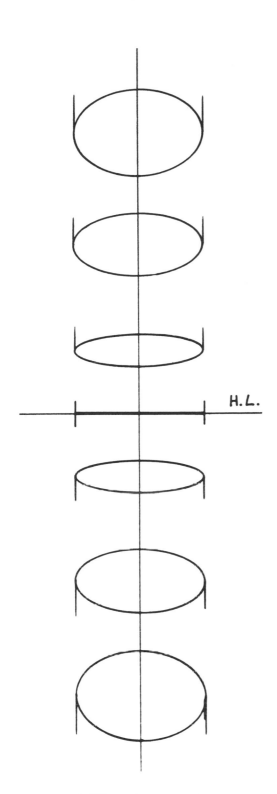

H.L.

4. *Ellipses in perspective*

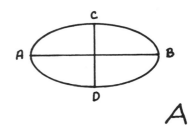

A

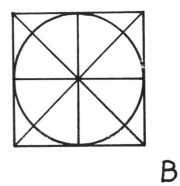

B

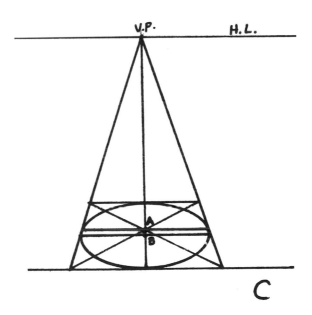

C

5. *Geometric ellipses*

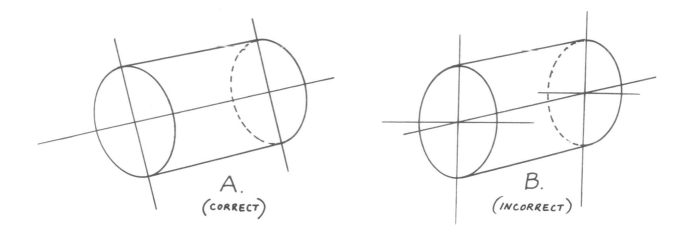

6. *Tilted circular objects*

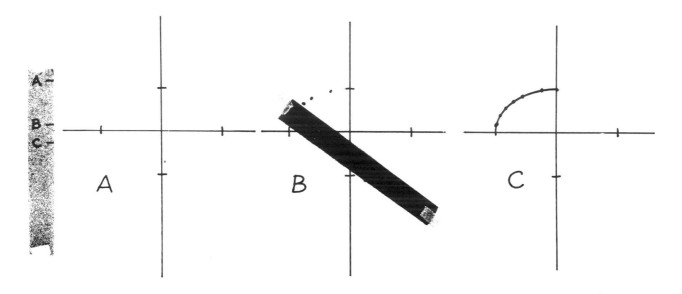

7. *Drawing an ellipse*

Rule. *The minor axis of the ellipse coincides with the center line of the object.* This rule is illustrated in Figure 6, which shows the common error made in drawing tilted circular objects.

MECHANICAL METHODS OF DRAWING ELLIPSES

It's possible to buy ellipse template guides and other gadgets to help you draw ellipses. One of the drawbacks of using a template ellipse guide is that the ellipse you want to draw may not be the size of the template. When you use a template you're limited to its size. The method I recommend allows you to draw any size ellipse. All you need is a pencil, a ruler, and a piece of paper.

First determine the length and width of the ellipse (major and minor axes). On the edge of a strip of paper, mark off half of the major axis and half of the minor axis (Figure 7A); *ac* is half the major and *ab* is half the minor. Line up point *b* on the major axis and point *c* on the minor axis. Move the paper strip counterclockwise making dots as you go (Figure 7B). Make as many dots as you need to draw one-quarter of the ellipse (Figure 7C). To complete the ellipse, repeat the procedure for the remaining three quarters, or if you prefer, simply trace the finished quarter and transfer it to the other three quarters.

We've barely scratched the surface of a most fascinating science. I've tried to touch on what I think are the major basic rules of perspective that will help in still life painting. But if your curiosity has been aroused, I once more strongly recommend that you investigate the subject more fully.

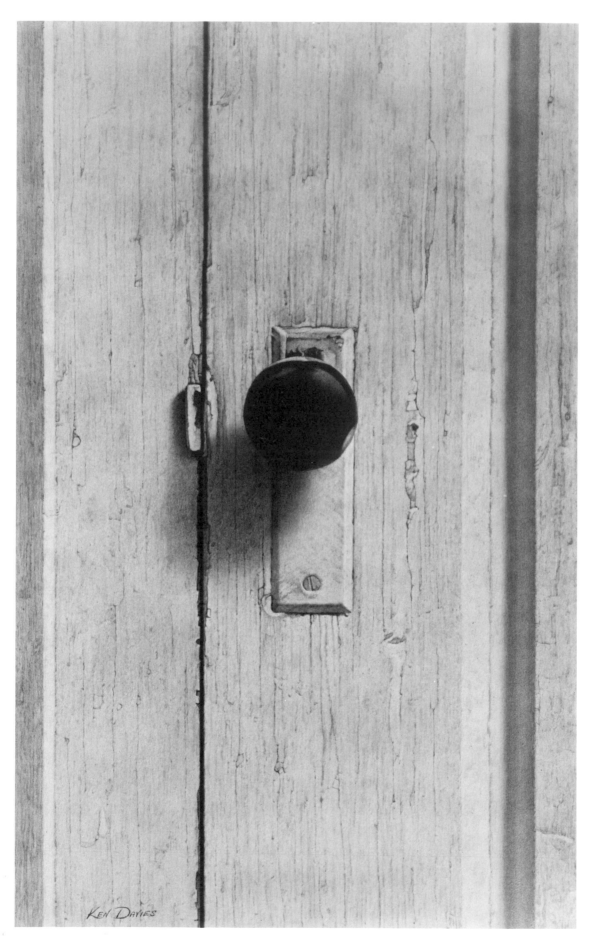

Back Door Knob

PART ONE **PROJECTS**

1 LINE DRAWING

Assignment 1 **Simple Shapes**

Assignment 2 **Complicated Shapes**

Assignment 3 **Crumpled Paper Bag**

Assignment 4 **Symmetrical Objects**

Assignment 5 **Ellipses**

2 BLACK AND WHITE VALUE DRAWING

Assignment 1 **Ball, Cone, Cylinder, and Block**

Assignment 2 **Still Life on White Charcoal Paper**

Assignment 3 **Still Life on Gray Charcoal Paper**

3 BLACK AND WHITE VALUE PAINTING

4 COLOR PAINTING

Assignment 1 **Value Scale**

Assignment 2 **Matching Chart**

These projects, and the exercises which follow in
Part Two, are designed to give you some practice
in seeing *shapes*, *values*, and *colors* and record-
ing them accurately with oil paint.

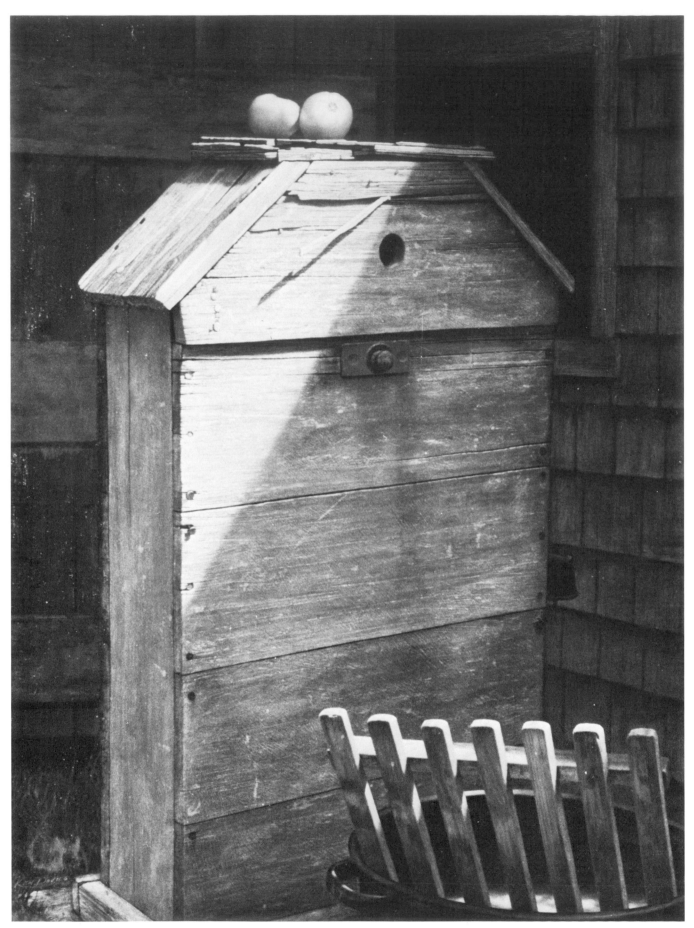

Ripe Fruit

PROJECT 1　**LINE DRAWING**

Beneath every good painting there should be an accurate line drawing. In painting still lifes, sharp illusions of reality will depend partially on that drawing. In sharp focus painting the line drawing can be defined as a rendering of the outline shapes of objects. The textures of the objects will be disregarded for the present.

There are five assignments in this first project which should enable you, with practice, to produce a still life drawing that is accurate in shape and perspective. Mechanical methods will be used, and learning to master them will give you satisfaction in the knowledge that your eye and hand together are capable of producing a correct drawing. Practice and repetition of the assignments will eventually obviate the further use of mechanical aids to drawing. I can't stress too much how important it is to keep making one drawing after the other, for a good line drawing is an important foundation to a good painting.

MATERIALS AND EQUIPMENT

Bond pad, 14" x 17"
Drafting pencil with HB and 2H leads
Eraser
Plumb bob
Carpenter's level
Ruler
Tracing pad, 14" x 17"
Masking tape

In each of the following assignments, place the still life objects on a flat surface, making certain the setup is slightly below eye level. If you prefer to stand at an easel, raise the setup so that you are viewing it from slightly above.

Assignment 1 **Simple Shapes**

Use a group of simple objects, such as a wooden block from a child's set, a rubber ball, a cardboard cereal or cracker box with the outer paper removed, a cone, and a cylinder (Figure 1). Make the cone by twisting a piece of white paper into shape and taping it in place. The cylinder can be made by covering an empty salt container with white paper. Since you'll be drawing only the outline shapes or edges, of these objects, their surfaces should be smooth. The textures of the objects and the shadows they cast will not be dealt with in this assignment.

Rough Sketch. View the setup and determine the proportions and relative sizes of the objects. Make a rough sketch of the setup on the bond pad, using a drafting pencil with an HB lead (Figure 2). Don't make your sketch too small; try to make the objects life-size. With the aid of the carpenter's level and the plumb bob, place dots locating the corners and tops of the objects in the rough sketch. The dots will make it simpler to correct the drawing.

Correcting Perspective. Check for correct perspective in the rough sketch using the carpenter's level and the plumb bob. Hold the carpenter's level at arm's length between you and the setup (Figure 3). Move the level until the small air bubble in the glass cylinder is centered. This will enable you to determine whether the top of the ball is lower than the top of the box, whether the top of the cylinder is higher or lower than the cone, and so on. In this way, check the *horizontal* position of each object in relation to the others. As you check these measurements, refine your rough drawing. It may be necessary to raise or lower the position of an object.

To illustrate the measurements made by the level and plumb bob, I have added horizontal and vertical lines to the rough sketch (Figure 4). It is not necessary to draw these lines on your rough sketch.

With the plumb bob held between you and the setup, check the vertical measures to find where one object overlaps the other (Figure 5). Using the pencil dots, correct the drawing.

Completing the Drawing. Using the dots as checkpoints, it should now be relatively simple to finish the outline drawing of the objects. The final drawing should show a neat outline of each object in its correct relationship to the others. Erase all remaining rough sketch lines (Figure 6).

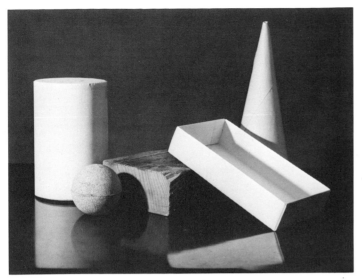

1. *Setup of simple shapes*

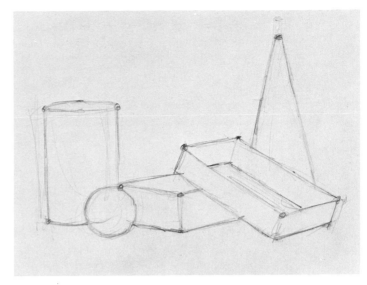

2. *Rough sketch*

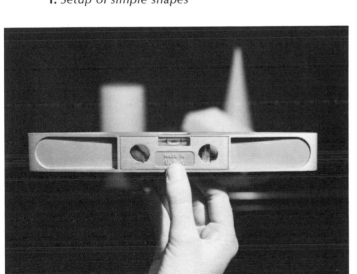

3. *Carpenter's level*

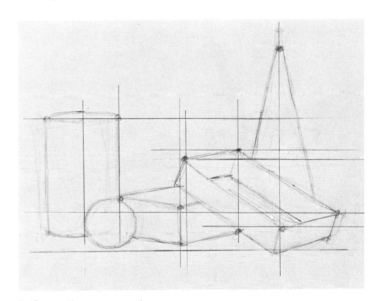

4. *Correcting perspective*

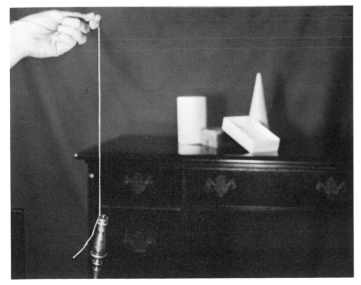

5. *Plumb bob*

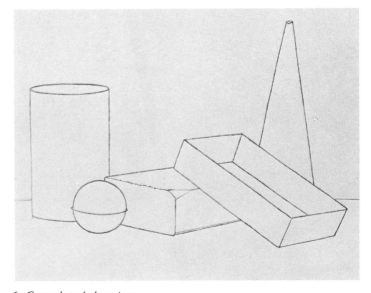

6. *Completed drawing*

Assignment 2 **Complicated Shapes**

Select a cup, an apple, a jug, a book, a saucer, and a cardboard box (with the cover left open). The objects should have no lettering or decoration on them.

Rough sketch. Repeat the drawing procedure as in Assignment 1, drawing with the HB pencil on the bond pad.

Correcting Perspective. Using carpenter's level and plumb bob, correct your drawing as you did in Assignment 1.

Completing the Drawing. Complete the outline of the still life setup; then erase all superfluous sketch lines (Figure 7).

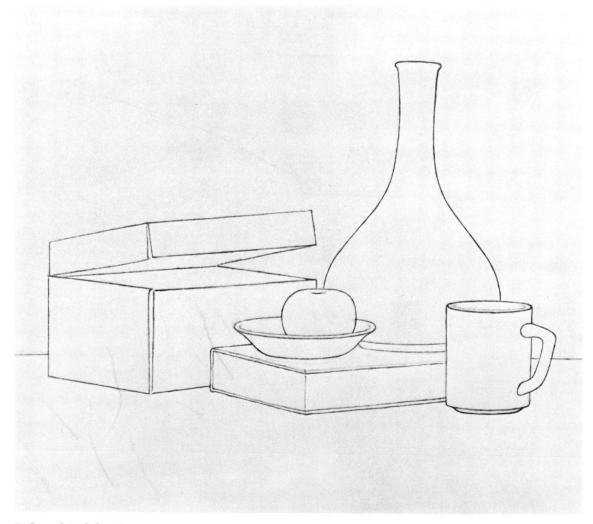

7. *Completed drawing*

Assignment 3 Crumpled Paper Bag

In this assignment, you'll draw one of the most complicated shapes of all—a crumpled paper bag. Use a plain brown paper bag, crumpled down to about half its original size.

Correcting Perspective. With the carpenter's level and plumb bob, check one wrinkle against the other. This is the real test of what you learned in the first two drawings but made more complicated by the shapes within the bag.

Completing the Drawing. The finished drawing should contain not only the outline of the bag itself but all of the interior wrinkles as well (Figure 8).

8. *Completed drawing*

Assignment 4 **Symmetrical Objects**

Choose a symmetrical object, that is, one in which both sides are identical—if it were cut down the middle, each half would be a mirror image of the other. A bottle or jar is suitable. Place the object on a table, just below your eye level.

Rough Sketch. Using the bond pad and the HB pencil, make a rough drawing of the object.

Refining the Drawing. On the rough drawing, find the center of the *top* of the object with your eye and place a pencil dot at that point. Find the center of the *bottom* of the object with your eye and place a pencil dot at that point. With the ruler, draw a line from the top dot to the bottom dot, extending the line slightly above and below the object. Correct one side of the drawing, and darken the outline. Place a piece of tracing paper over the outline of the corrected side and tape each top corner lightly to the drawing with bits of masking tape. With a very sharp 2H pencil, trace the center line that you've ruled in. Trace the corrected side of the object. Lift the tracing paper; turn it over, and place the drawn side face down on the uncorrected side of the rough sketch. The tracing of the corrected side is now on top of the uncorrected half of the drawing. When the center-line top and bottom dots are in perfect register, tape the tracing paper down again. Retrace the outline of the perfect side. It will transfer to the drawing paper. Remove the tracing paper and darken the outline (Figure 9).

Completing the Drawing. Erase the center line and all rough sketch lines.

Note. This is a mechanical method of drawing a symmetrical shape, but precision is necessary in sharp focus still life painting. The purist may claim that this is an artificial way of drawing, but I find that it's rare that the hand can be trained to draw precisely without the use of instruments. I don't like to sound dogmatic—after all, there may be the exceptional person who can draw with perfect accuracy—but the beginner will surely need mechanical aids. And, quite frankly, I still use them.

9. *Refining the rough sketch*

Assignment 5 **Ellipses**

Because ellipses are difficult to draw, this assignment is designed to give you lots of practice in drawing them. For your setup, you'll need a selection of round or cylindrical objects. You'll find that *any* circle in perspective becomes an ellipse (see A Lesson in Perspective). Place the objects on a table slightly below your eye level, tilting each of them to create ellipses at varying angles (Figure 10). Some ellipses are almost full circles while others are flattened.

Rough Sketch. Make a line drawing of the objects on the bond pad with the HB pencil.

Refining the Drawing. With the carpenter's level and plumb bob, correct and refine the drawing and erase all rough sketch lines (Figure 11). Eventually you should be able to eliminate the level and plumb bob entirely. As you develop skill through repetition of these assignments, you'll find that locating check points becomes automatic.

10. *Setup of ellipses*

11. *Completed drawing*

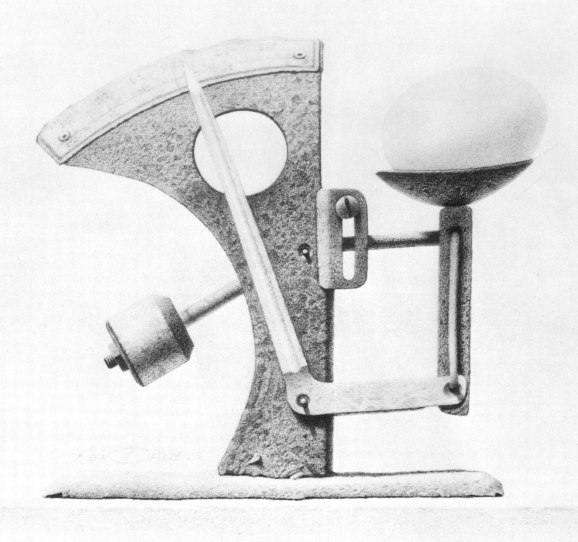

Egg Grader (study)

PROJECT 2
BLACK AND WHITE VALUE DRAWING

My students at Paier School got so tired of hearing me scream, "Darker, darker!" that they finally tacked signs up around the studio that read "Darker." After that incident, all I had to do was point mutely at the signs in order to get the idea across that they had the beginner's overwhelming tendency to make the dark areas of their drawings and paintings read too light. If you can become aware of what creates values, you won't be afraid of the darks!

WHAT IS VALUE?

Value refers to amounts of light and dark that you see. Simply speaking, a white piece of cloth is a *light value*, a black piece of cloth is a *dark value*, and a gray piece of cloth is a *middle value*. However, in addition, *the value of an object is primarily determined by its local color and the amount of light shining on it*. Local color refers to the color of an object. For example, the local color of an apple is usually red. Since this project deals with black and white value drawing and not with color, let's concentrate here only on the amount of light shining on the surface of an object.

When a light shines directly on a matte surface you'll see *dark*, *light*, and *middle* values depending on how much light is reaching the surface. If the object is curved, such as an egg, the values will be graduated without discernable boundaries along the curved surface. If the surface is flat and contains two or more planes, such as a block of wood or a paper box, the change in values will be sharply delineated (Figure 1).

In the study of light and shade, we can reduce the values into five basic types: (1) *direct light*, or light that hits a surface straight on to create a highlight; (2) *halftones*, or tones which are created when the surface planes turn away from the light source to receive less light; (3) *shadow*, or planes facing away from the light source which receive no direct light at all; (4) *reflected light*, or light coming from the direct source which has ricocheted off another surface into the shadow area (this light prevents shadows from being totally black); and (5) *cast shadows*, or the dark area caused when an object is placed between the light source and another surface (a good example is the darkness during a solar eclipse which is caused by the cast shadow of the moon passing between the sun and the earth).

LEARNING TO SEE VALUES

Let's return to the problem of getting darks in a drawing to read as dark as they really are. Although difficult, it's vital when *recording* values accurately that you *see* them correctly. The following hints may help you to overcome this fairly predictable problem.

Squint. Narrow your eyes and peer at your setup, then at your drawing. Setup, drawing; back and forth. Squinting makes the values appear sharper, and they are therefore easier to correct.

Cup Your Hand into a Tunnel. Peer through the tunnel at the setup, then at the drawing. Cross-check as you did while squinting.

Be Aware of the Values Surrounding an Object. The value of the object you're sketching can be deceiving depending upon the values around it. A gray square surrounded by white appears darker than a gray square surrounded by black, yet they are both the same value of gray (Figure 2). Train yourself to see these relationships.

Refer to the Value Scale. Compare the grays in your drawing and setup to the values on the *Value Scale* in the color section.

Don't Be Discouraged. The best way to overcome the problem of seeing darks and lights correctly is through experience. Keep making value drawings. Don't be discouraged by failure. Sometimes even fourth-year students find themselves wrestling with this problem.

MATERIALS AND EQUIPMENT

White charcoal paper, 19″ x 25″
Gray charcoal paper, 19″ x 25″
Charcoal pencils, 2B, 4B, 6B
White Conté pencil
Sandpaper block
Single-edged razor blade
Kneaded eraser
Carpenter's level
Plumb bob
Shadow box
Clip-on light with incandescent bulb
Drafting table lamp with neutral fluorescent tube
Fixative

In each of the three assignments that follow, be sure that the setup is slightly below eye level as you work. Use the clip-on light to illuminate each setup. Use the drafting table lamp to light your work surface. Pad your work surface with several sheets of paper so that the irregularities of the tabletop do not show up on your drawing.

1. *Value variation on objects with different shapes*

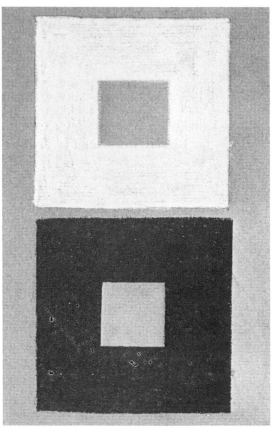

2. *Surrounding value change causing visual shift*

Assignment 1 **Ball, Cone, Cylinder, and Block**

Place the ball, cone, cylinder, and block side by side on a table. Don't let them overlap each other. Light and shadow can be controlled by changing the angle of the shade on the clip-on light (Figure 3).

Line Drawing. Use the carpenter's level and plumb bob to aid you in making a line drawing of the setup in correct perspective. However, if you've practiced the Line Drawing Assignment in Project 1, you may not feel that you need tools any longer to draw in perspective. Sketch the outlines of the objects and the shapes of the shadows. When the line drawing is complete, check it for correct perspective.

Shading Process. It will be possible for you to shade the ball, cone, cylinder, and block with confidence if you first reproduce the Shading Chart (Figure 4). Do this slowly and carefully, then proceed to shade your line drawing in the same manner.

Holding the 2B charcoal pencil lightly, move the pencil in a gentle, circular motion, in back-and-forth movements, or with a cross-hatching effect. Use the 2B pencil for producing light values, the 4B pencil for middle values, and the 6B pencil for dark values. Prevent your pencil leads from becoming stubby by sharpening them to elongated points with a razor blade. Rub the points frequently on the sandpaper block. Build up the shadows until you arrive at the correct values. The slower you build up the shadows, the smoother your rendering will be (Figure 5).

At this stage, don't use your fingers to smudge the shadows. Beginners can make a drawing look too overworked in this way. Avoid using paper stumps (see Glossary) as well. They are often fine for blending, but, improperly used, they can ruin a clean drawing. For the time being, learn to shade the hard way. That is, by using many fine pencil strokes (Figure 6).

3. *Setup*

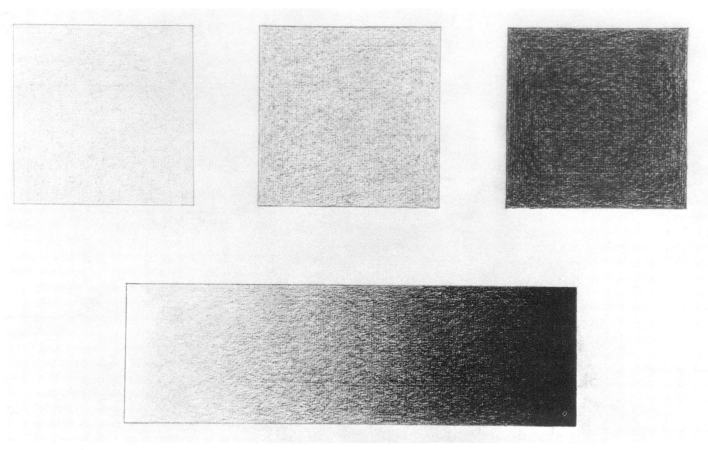

4. *Shading chart*

5. *Shading with charcoal pencil*

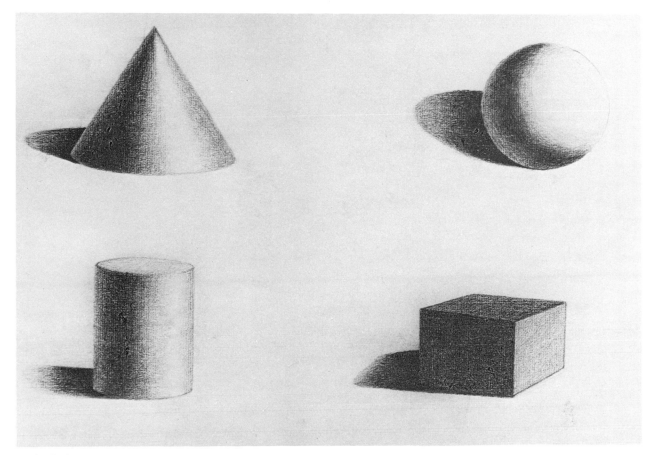

6. *Shaded forms*

Assignment 2 **Still Life on White Charcoal Paper**

In a shadow box, arrange the objects to your own taste. Light the setup with the clip-on light. The shadow box must shut out most of the light within the room. Control the light on the setup in the shadow box with the clip-on lamp to create one main source of light.

Line Drawing. Make a line drawing on a half-sheet of white charcoal paper with the 2B charcoal pencil. Correct the perspective with the carpenter's level and plumb bob, if necessary.

Shading Process. Repeat the shading procedure as in Assignment 1. As you continue to shade the drawing, remember to work from the background to the foreground objects. Keep checking the related values for correctness. Spray the completed drawing with fixative to prevent smudging (Figure 7).

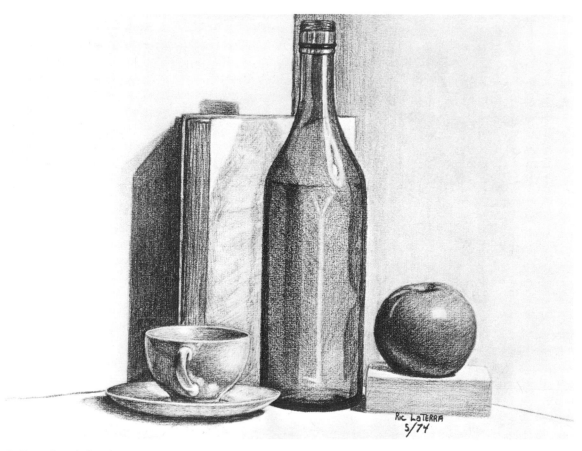

7. *Completed drawing*

Assignment 3 **Still Life on Gray Charcoal Paper**

Set up a still life using the same objects as in Assignment 2. Rearrange them to form a different composition in the shadow box. Light them with the clip-on light.

Line Drawing. On a half-sheet of gray charcoal paper, make a line drawing of the setup with charcoal pencils. Check for correct perspective.

Shading Process. The only notable difference between shading on white paper and shading on gray paper is that the gray paper acts as a value and the white Conté pencil is used for highlights. The gray paper is approximately a middle-gray value. Each area in the setup equal to the value of the gray paper should be left untouched. Each area in the setup that is darker than the value of the gray paper should be shaded with charcoal pencils. Any area that is lighter than the gray paper should be highlighted with white Conté pencil (Figure 8). Let me caution you not to blend the white and black pencil strokes together. If you do, you'll get a muddy or dirty tone quality that's inconsistent with the clarity of values you are trying to achieve in your drawing.

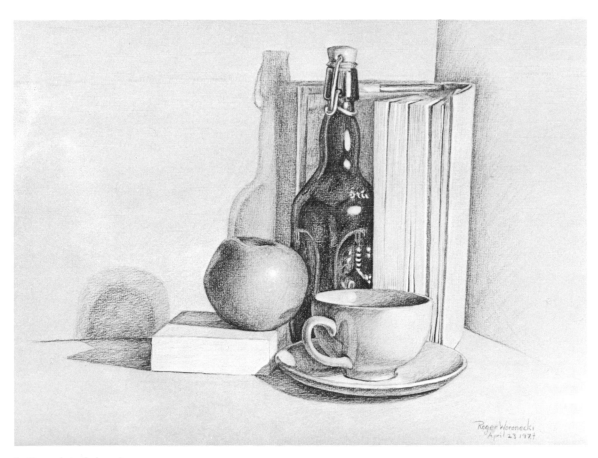

8. *Completed drawing*

Edaville Railroad

PROJECT 3
BLACK AND WHITE VALUE PAINTING

With a good understanding of the nature of values, it's relatively easy to make the transition from charcoal pencils to oil paints. Only black and white oil colors will be used in this assignment. As you continue to increase your perception of values you'll also start to familiarize yourself with oil paints. If you've never used them before, now is the time to get used to handling them without the added complication of mixing colors.

MATERIALS AND EQUIPMENT

Drawing supplies (same as in Projects 1 and 2)
Fixative
Canvas boards (two or more), 11" x 14"
Ivory black oil paint
Titanium white oil paint
Linseed oil
Small metal cup
Turpentine
Palette knife
Palette
A mahlstick, used for painting details or whenever you want finer control of the brush
Paint rags and a large phone book for cleaning brushes
Use the same five objects as in Assignment 1 of Project 2: a ball, cone, cylinder, block, and box. Arrange them in the shadow box. Light the setup with the clip-on light.

Time limit: four hours for each painting.

Line Drawing. Make a line drawing on an 11" x 14" canvas board with the 2B charcoal pencil. Draw the outlines of each object and the shapes of the shadows (Figure 1).

Correcting Perspective. Correct the perspective of your drawing, using the carpenter's level and plumb bob.

Fixing the Drawing. Spray the finished drawing with fixative to set the charcoal lines and prevent smudging.

Preparing the Paints. On your palette, squeeze out some black paint about the size of a quarter. Squeeze out an equal quantity of white paint. Pour a small amount of linseed oil into a metal cup. When mixing oil paints, you usually add a medium to make the paint spreadable yet not so thin that it is transparent. I suggest you use linseed oil for the time being; however, there are many other types of artist's mediums in the stores and the painter should eventually experiment with all of them.

Mixing the Paints. View the setup and estimate the values. Then mix the black and white paints on your palette in varying proportions until you've obtained the right gray for each corresponding value in the setup.

Direct Painting. Always start by painting the background, then move into the foreground. This procedure makes it easier to determine the value of a foreground object as it's seen against its actual background. Keep mixing and applying the grays to the proper areas. Choose a brush suitable to the size of the area in which you're working; for example, a broad area should not be covered with a very small brush (Figure 2).

Blending. When one value merges with another you'll need to blend the area. To do this, determine each and every square inch of value in the area. Then mix each of the corresponding grays, and apply them correcting the values as you go (Figure 3).

If the values on an object change gradually, special brush techniques can be used for blending. Use a dabbing and/or stroking motion with your brush along the edge to be blended. If the values are sharply defined, the edges should be left hard and unblended. Don't be too concerned with perfect blending at this point. You'll find that it will become easier as you discover your own methods through experience. Right now consider it more important to achieve the accurate values in each area (Figure 4).

Painting Practice. On an 11" x 14" canvas board, make another black and white oil painting using more complicated objects in your setup—jugs, bottles, cups, books. This will further test your skill in determining values and using oil paints. Don't stop with just two black and white oil paintings; keep on arranging new setups with even more complicated objects.

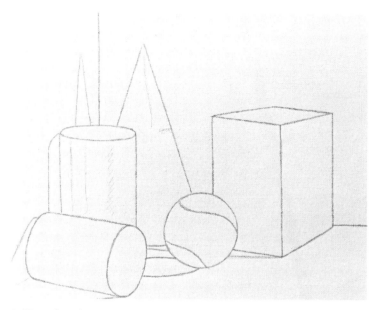

1. *Line drawing*

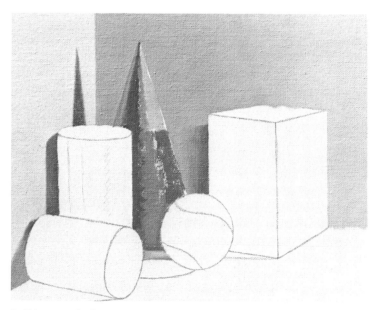

2. *Direct painting*

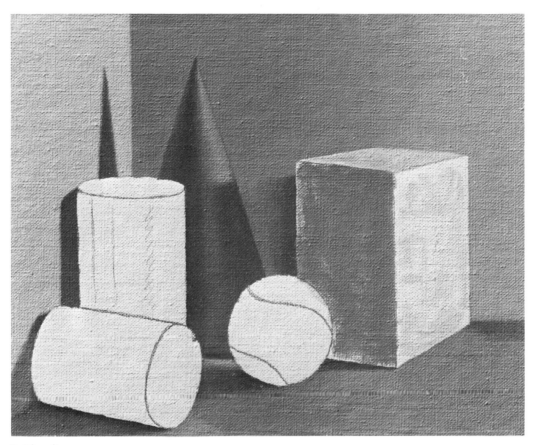

3. *Blending*

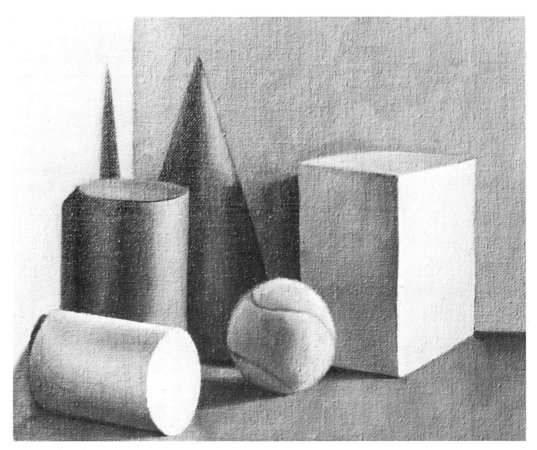

4. *Completed painting*

Academic Procession

PROJECT 4 COLOR PAINTING

After completing the first three projects, you should be accustomed to recording shapes and values accurately. Now you reach a turning point which I hope you've been anticipating with great enthusiasm: the use of *color*. From now on you'll not only have to draw a shape and determine its value, but you'll also have to determine its color.

THE COLOR WHEEL

Reduced to its simplest form, the color of pigment represented by the color wheel consists of the three *primary* colors: red, yellow and blue. The *secondary* colors are achieved by mixing red and yellow to make *orange*, red and blue to make *violet*, and blue and yellow to make *green*. The primary and secondary colors form a simple color wheel. Purchase one at an art supply store and refer to it during this project.

Opposite colors on the wheel are called *complementary* colors. Examples are red-green, orange-blue, and yellow-violet. Any two colors found next to each other on the wheel are termed *analogous* colors. Examples of these are red-violet, red-orange, and blue-green.

When complementary colors are mixed together, they neutralize to form *gray*. Most color wheels have a gray circle in the center to indicate that when true complements are mixed, the result is gray, or neutral. This phenomenon will be of utmost importance to you from now on. Remember it. In fact, try to memorize all of the preceding information. Even though it's elementary, you might consider it a necessary refresher. At Paier School, I used to walk up to a student, point at him and demand, "What's the complement of blue?" I expected a fairly prompt response. Try that on yourself from time to time. I was often amazed at the number of second-year students who still hadn't memorized this simple color information. Another tip—keep referring to the color wheel while you're painting.

As you know, there are many shades of red, ranging from bright to dull. When trying to match a particular red, you'll seldom be able to use red pigment straight from the tube. You'll have to add other colors to the tube color to mix the right shade. Knowing that an amount of green added to the red will gray or neutralize it is therefore critical. For further information on color theory you should read a book dealing with one of the well-known color systems, such as Albert H. Munsell's (available in *Grammar of Color: A Basic Treatise on the Color System of Albert H. Munsell*, edited by Faber Birren), or ask your art supply store for color charts. These color systems give you a thoroughly scientific breakdown of the *hue*, *value*, and *chroma* (intensity) of color.

Color Temperature. Another important fact worth memorizing is this: when you add white to a color, that color is altered in three ways. It's *cooled*; it's *lightened*; and it's *grayed*. Although we've discussed *value* and the related terms *graying* and *lightening*, I haven't mentioned the fact that a color also has *temperature*. That is, it's either *warm* or *cool*. Generally, reds, oranges, and yellows are considered warm colors, while blues, greens, and violets are cool colors. However, warm and cool versions of *all* colors are possible. For instance, a green with a preponderance of yellow added would be a warm green. A green with a preponderance of blue would be a cool green.

Color Relativity. Whether a color is warm or cool, bright or gray depends to a great extent on the colors around it. When discussing black and white value, I referred you to an illustration of a gray square surrounded by a black border and a gray square surrounded by a white border (see Project 2, Figure 2). In the same way, if you substitute the gray square

with *any color* and surround it with a variety of *other colors*, you'll find that the color of the square is altered. As an example, paint a blue square and surround it with a border of yellow. Then experiment by surrounding it with other colors on the wheel. Notice that each new color causes the blue square to appear to change in either value, color, or chroma. It might be a good idea to devote some time to experimenting with these color juxtapositions. The number of hues, values, and intensities is infinite, and some artists have spent lifetimes on this type of color experiment or on expanding this basic idea. So play with the colors. It's fun to make your own discoveries.

Armed with the above color information, you're ready to start painting the first of two color charts. I consider these charts by far the most important color exercises in this book. The better job you do on them now, the wiser and better prepared you'll be for the exercises that follow.

MIXING COLORS

In the Assignments in this project, you'll practice mixing and painting colors according to the Value Scale and Matching Chart in the Color Plates. Below are some important suggestions on procedure for mixing colors.

Red Scale. I suggest that you start with *cadmium red light*. Find its match in the Value Scale. Paint that rectangle first. To lighten it, add white. To darken it, add the following colors, one after the other: *cadmium vermilion, cadmium red deep, alizarin crimson,* and *black.*

Orange Scale. Mix approximately equal parts of *cadmium yellow light* and *cadmium red light.* Find its match on the Value Scale. Paint it in the corresponding rectangle. To lighten it, add white. To darken it, add *burnt sienna,* then *burnt umber* and *black,* either singly or in combination.

Yellow Scale. Start with *cadmium yellow light.* Find its match on the Value Scale. Paint it in the corresponding rectangle. To lighten it, add white. To darken it, add *yellow ochre, raw sienna,* and *raw umber.*

Green Scale. Start with *permanent green light.* Find its match on the Value Scale. Paint it in the corresponding rectangle. To lighten it, add white. To darken it, add *viridian green* and *black.*

Blue Scale. Start with equal parts of *cerulean blue* and *cobalt blue.* Find its match on the Value Scale. Paint it in the corresponding rectangle. To lighten it, add white. To darken it, add *ultramarine blue* and *black.*

Violet Scale. Start with *cerulean blue* and *alizarin crimson.* Locate the color on the Value Scale. Paint it in the corresponding rectangle. To lighten it, add white. To darken it, add *ultramarine blue, alizarin,* and *black.*

Before all the purists jump down my throat, let me explain that this is a very arbitrary series of colors and mixtures. Their purpose is to help the beginning oil painter to find darks and lights of each of the six colors of the basic color wheel. These suggested mixtures are meant to be a jumping-off point, since there are many other ways to mix the same colors. I don't claim, either, that these mixing formulas are as scientifically accurate as those you would find in the Munsell color system. But, as a practical approach, they work.

Light Colors in Dark Values. One of the most important things you can learn at this point is that a very *light color,* such as yellow or orange, can be reproduced at a very *dark value.* Let's use yellow as an example. You'll find that raw umber, straight from the tube, is needed to mix the darker tones on the yellow column of the Value Scale. For some rea-

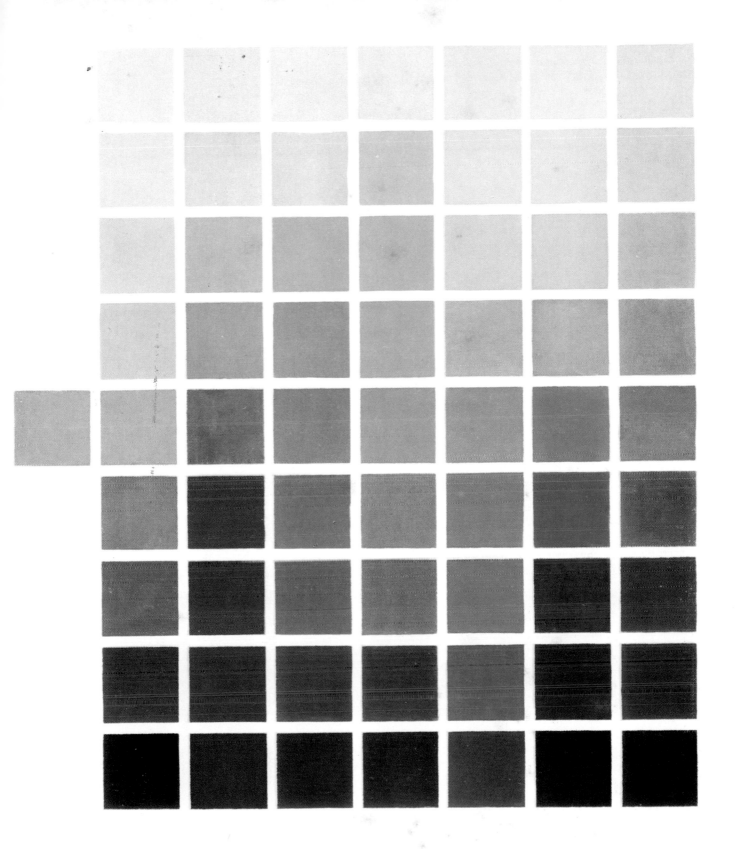

Value Scale. *This hand-painted chart shows a black and white value scale as well as value scales of each of the six basic colors of the color wheel. The neutral gray square on the left is a "middle" or #5 value (since it is adjacent to the fifth row of the value scale). The gray square immediately to its right was painted with ivory black and titanium white, while the isolated gray square was painted by mixing complementary colors.*

son, it's very hard to convince the student that *straight raw umber is really yellow*. Try to think of raw umber as a dark version of yellow. I'll predict that if you make a mistake in matching any color on the Value Scale, the dark values of the yellow and orange column are where you'll err most often.

Let's attempt to prove that yellow is raw umber. Hold a piece of plain yellow paper in an area of deep shadow. Squint at it. Now, move *part* of the piece of paper into the light. Compare the value of the paper in shadow with the value of the part in the light. Force yourself to think in terms of color. Notice that the yellow paper in the darkest part of the shadow is indeed pure *raw umber*. Or, it may be even darker! Perhaps it's as dark as *burnt umber*.

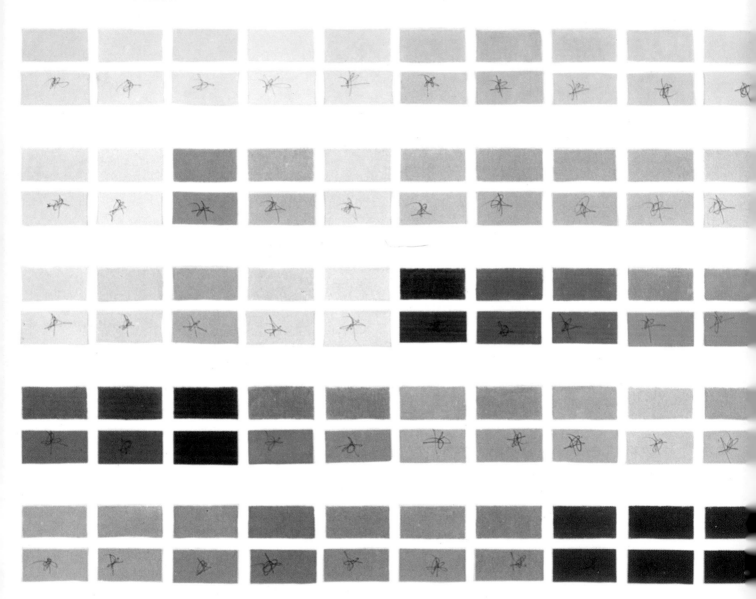

Matching Chart. *The paint chips on this chart are identified by initials. The blank color squares are painted to match the color chips as closely as possible.*

(text continues on page 65)

COLOR PLATES FOR THE EXERCISES

The final steps of the exercises presented in *Part Two: Exercises* (pages 67–128) are reproduced on the pages that follow.

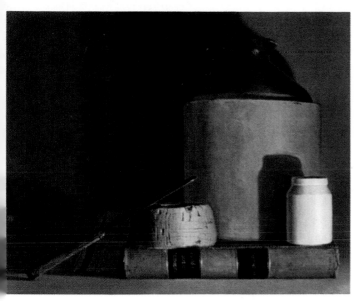

Exercise 1 *Color Still Life*

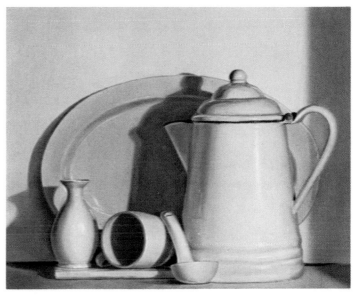

Exercise 2 *All-White Painting*

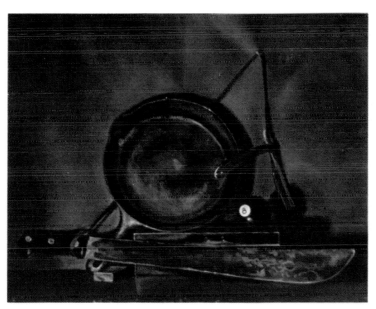

Exercise 3 *All-Black Painting*

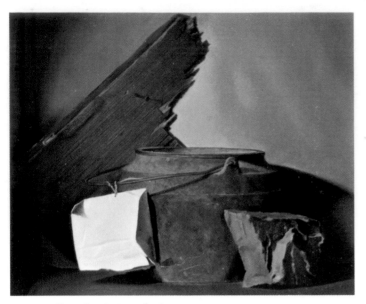

Exercise 4 *Rough Textures*

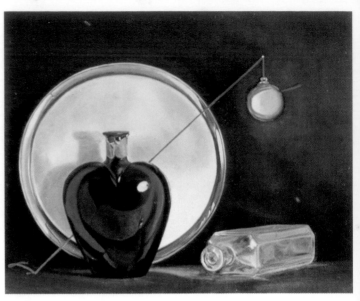

Exercise 5 *Smooth Textures*

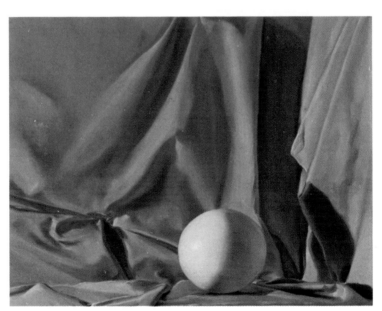

Exercise 6 *Reflected Light*

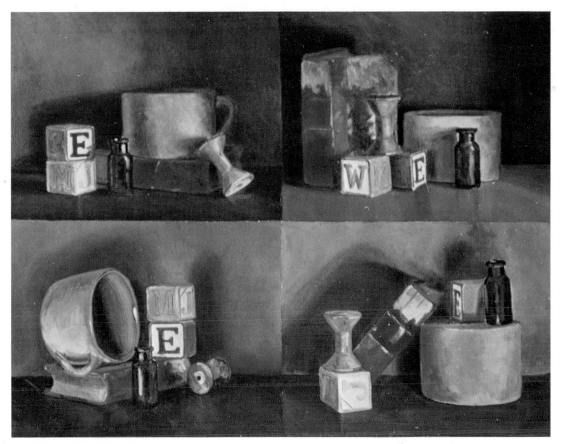

Exercise 7 *Speed Painting*

Exercise 8 *Speed Painting*

Exercise 9 *Monochrome Wet-into-Wet*

Exercise 10 *Drawing with a Brush*

Exercise 11 *Still Life under Red Light*

Exercise 12 *Still Life under Green Light*

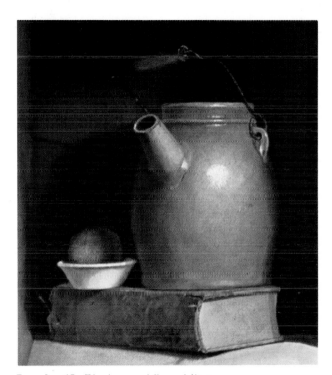

Exercise 13 *Glazing and Scumbling*

COLOR PLATES FOR THE DEMONSTRATIONS

The wash-in and block-in stages of the demonstrations presented in *Part Three: Demonstrations* (pages 145–186) are reproduced on the pages that follow.

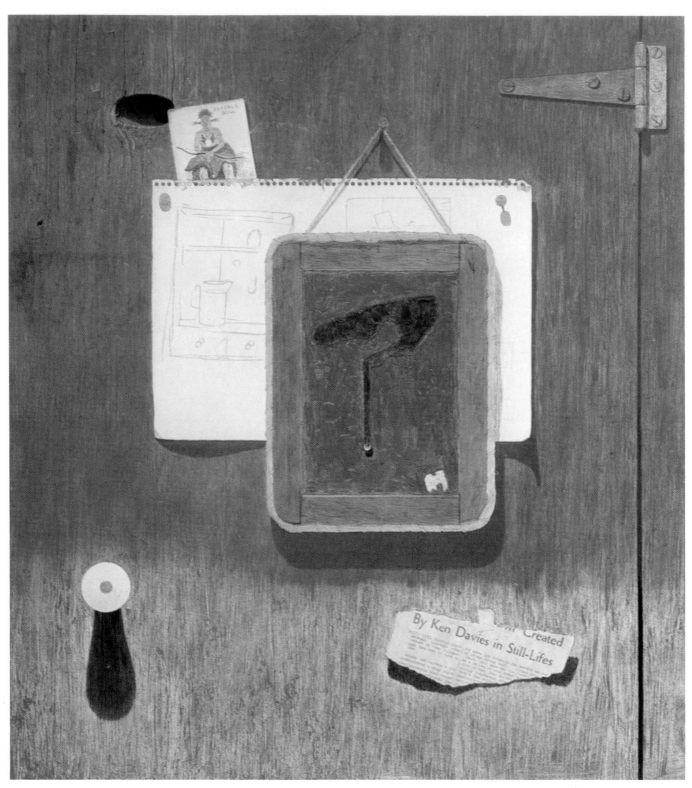

Demonstration 1 *From the Sketchbook. Wash-in*

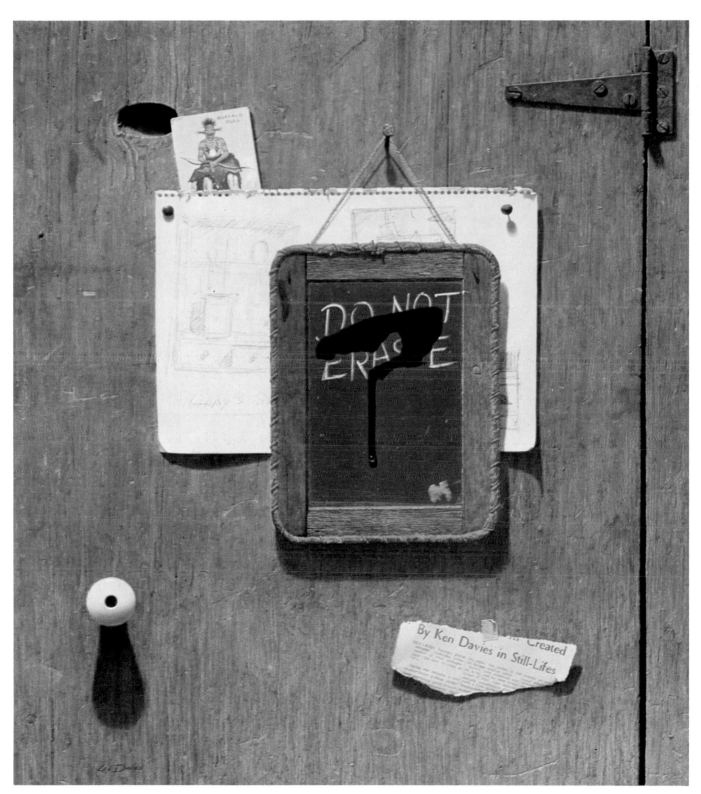

Demonstration 1 *From the Sketchbook. Completed painting*

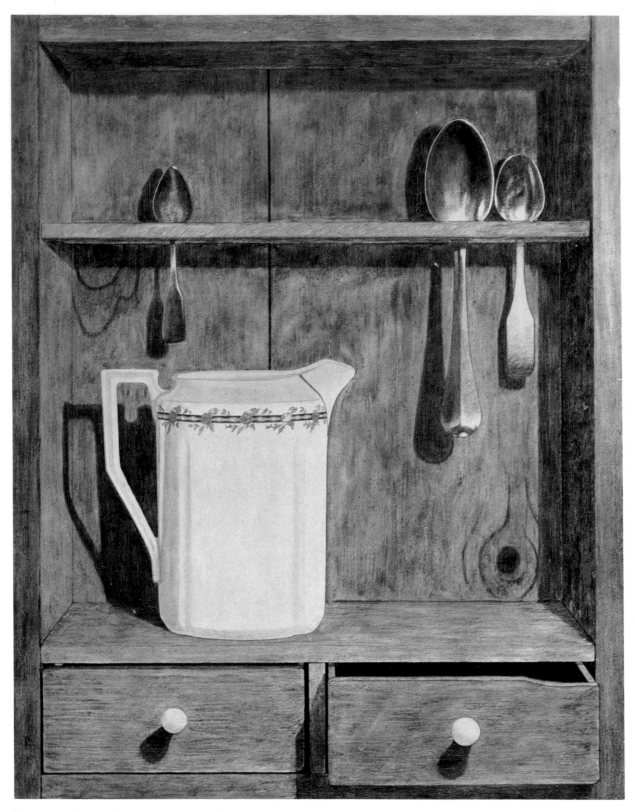

Demonstration 2 *Gray's Spoons. Wash-in*

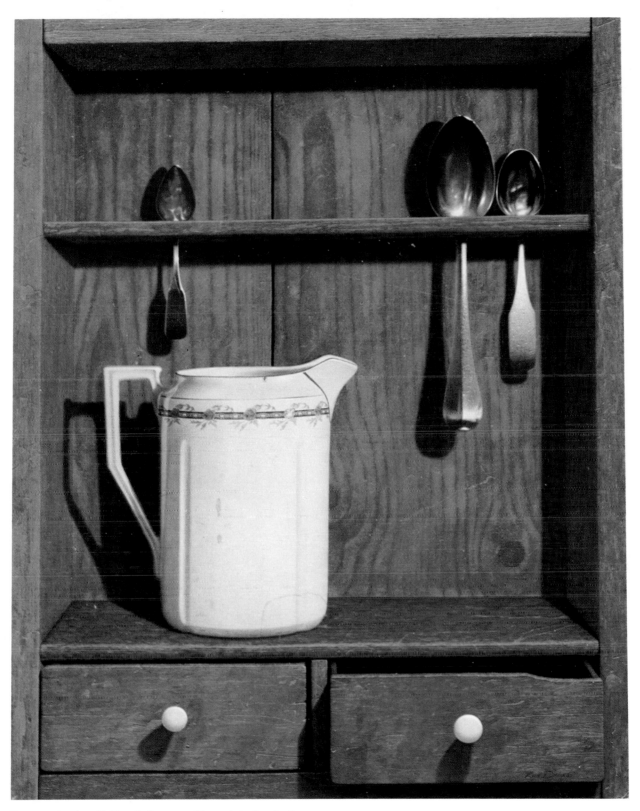

Demonstration 2 *Gray's Spoons. Completed painting*

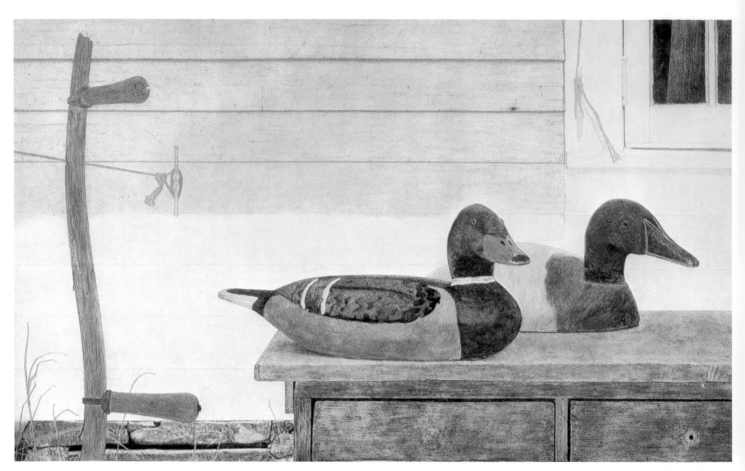

Demonstration 3 *A Gisler Mallard. Wash-in*

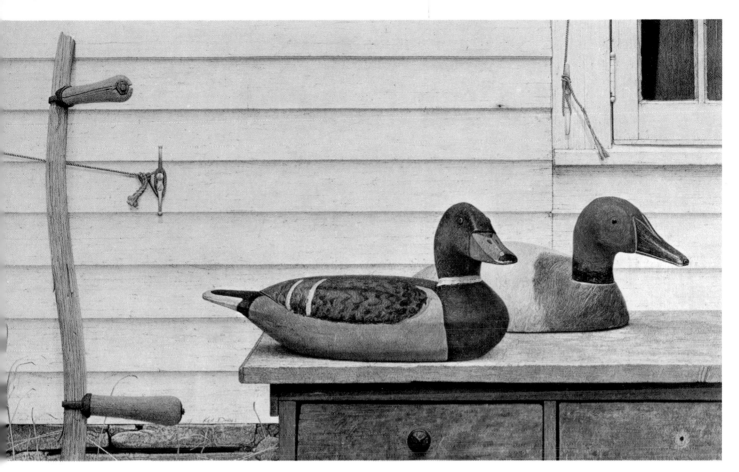

Demonstration 3 *A Gisler Mallard. Completed painting*

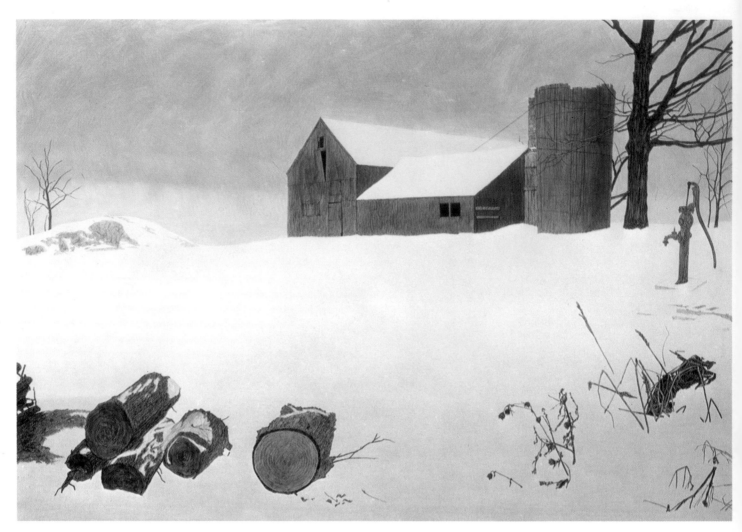

Demonstration 4 *On 139 Near 80. Wash-in*

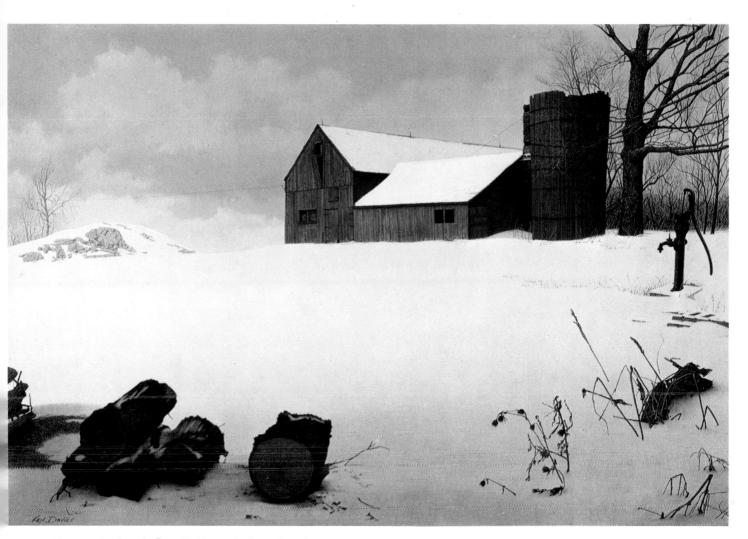

Demonstration 4 *On 139 Near 80. Completed painting*

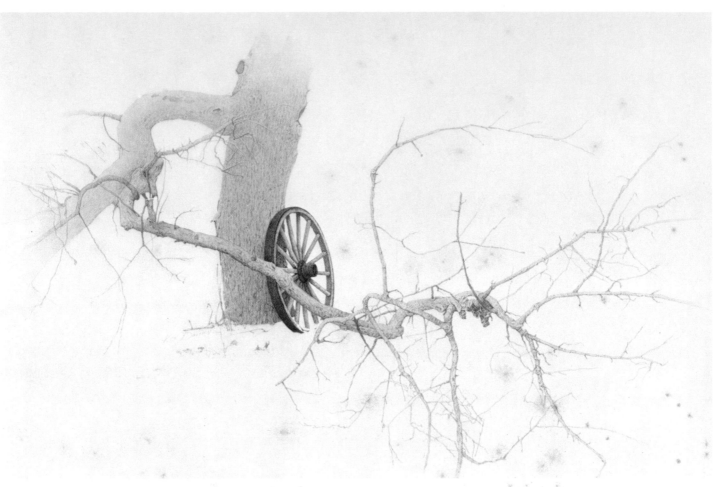

By the Driveway. *Many of the studies and sketches such as this one are a marvelous change-of-pace from the time-consuming finished paintings on Masonite panel. I paint them on double-weight illustration board using a 95% transparent oil wash (mixed with linseed oil and damar varnish) with a bare minimum of opaque color, generally only in the highlight areas. These paintings are often mistaken for watercolors.*

Assignment 1 Value Scale

Painting this chart will give the beginning oil painter the experience of mixing and then matching each of the six basic colors on the color wheel at each value on the Value Scale reproduced on page 49.

MATERIALS AND EQUIPMENT

Two canvas boards, 16" x 20"
Palette spread with full range of colors (see list in the chapter on Materials and Equipment)
Painting supplies
50 different colored paint chip samples from the paint store
Brushes
Pencil
Ruler

Preparing the Grid. Using a pencil and ruler, divide the canvas board into seven vertical columns and nine horizontal columns.

Painting the Grays. The first vertical column on the left is the black and white Value Scale, which ranges in nine steps from just off-white to just off-black. The exact middle of the Value Scale can be found in the fifth rectangle from the top. To reproduce this column, mix the grays by using ivory black and titanium white. Match all the grays and paint them in their corresponding rectangles.

Painting the Colors. Paint the remaining columns in reds, yellows, oranges, greens, blues, and violets to reproduce each of the six basic colors of the color wheel at each of the nine values found in the first column of the Value Scale.

When you've finished, squint at the values across any given line from left to right. You should find that the colors change while the values remain the same.

Assignment 2 **Matching Chart**

Examine the Matching Chart reproduced on page 50. The mounted color chips, which were obtained from a paint store, are initialed in ink. Just above each color chip is a rectangle in which the color of the chip was exactly matched and painted in oil colors.

How to Mix Black. In the Value Scale we've used ivory black primarily to darken the cooler colors. From this point on, eliminate ivory black from your palette. Why? Because very often the warm colors become muddy when darkened with ivory black. This is especially true for inexperienced oil painters.

It's possible to produce your own black by mixing *burnt umber* and *ultramarine blue*, and the resulting black is almost identical to the ivory black from the tube.

Mixing Grays. Handsome grays can be mixed quite successfully from various combinations of colors without using ivory black. Experiment with these on your palette:
(1) different combinations of *blues* and *browns* plus *white*;
(2) different combinations of *violets* and *yellows* plus *white*;
(3) different combinations of *reds* and *greens* plus *white*.
(Notice that what I'm saying is that complementary colors neutralize each other.)

You can get infinite variety and subtlety in gray tones by mixing them with colors rather than just black and white. This brings us to the small outcast rectangle on the left of the Value Scale. When mixing that gray use *no black paint*. That gray should be identical to the fifth rectangle in the first vertical column of the Value Scale. That small rectangle is final proof that you need never use black paint to mix gray.

Preparing the Grid. On the canvas board, measure ten vertical and ten horizontal rows as shown on the Matching Chart. In every other vertical row paste the color chips.

Mixing and Painting the Colors. Using the colors on your palette, mix the color of each paint chip and apply it to the space adjacent to it. Refer to the mixing instructions presented earlier in this project when necessary.

Painting Hints. Remember that complements neutralize each other; white paint cools, lightens, and grays a color. Matching the color chips correctly will mean much trial and error; some of the color chips will be much simpler to match than others. For example, those with tones closest to the tube colors will be easier to achieve. The more subtle tones will require more complicated mixing. Don't waste time struggling with a particular color if you can't get it to match the color chip. Give it your best try, then leave it alone. Go on to the next color and return to the problem color later. It's best to mix the easy colors first and to build your skill and ability gradually.

When you have finally surmounted the frustrations of completing the Matching Chart, you should be quite expert at matching almost any color you can see.

PART TWO **EXERCISES**

It isn't my intention that you paint completed works during these exercises. I hope instead that, like practicing the scales on the piano, you practice the development of hand-eye coordination toward the time you'll be producing a serious, finished painting.

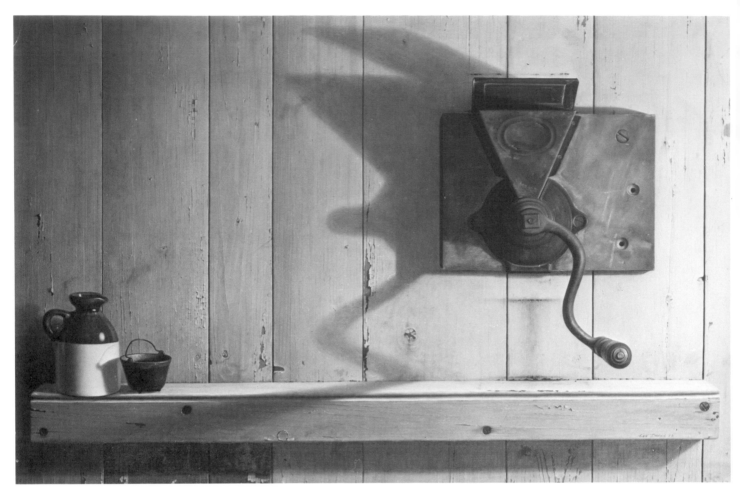

Antiques

EXERCISE 1 COLOR STILL LIFE

If you've accomplished the projects in the first part of this book, you already have a basis to paint a still life in oil colors. Skills that are faithfully developed are an important foundation of good painting, and if you're ready to develop your skills even further—to combine your knowledge of values with the use of colors—this is the moment you've been working for.

MATERIALS AND EQUIPMENT (Assignments 1 and 2)

Drawing supplies
Palette spread with full range of colors
Brushes
Canvas board, 16″ x 20″
Turpentine
Linseed oil
Shadow box (made from a large cardboard box)
Extra piece of cardboard to overhang top of shadow box and block out studio lighting
Clip-on light with incandescent bulb
Construction paper of any color
Masking tape
Retouch varnish
Varnishing brush, 2″
Choose any six objects, each a different color. Line the shadow box with colored construction paper. Light the setup with the clip-on light (Figure 1). Notice that the clip-on light is placed at an angle that maximizes the forms of the objects.

Time limit: eight hours.

Line Drawing. Using the drafting pencil on the canvas board, make a line drawing including the outline form of the objects and the cast shadows (Figure 2). Spray the drawing with fixative to prevent smudging.

Wash-in. Thin the paint with a mixture of ⅔ linseed oil and ⅓ turpentine. Wash the value and color of the background and each object into the foreground (Figure 3). The paint should be transparent, allowing the lines of the drawing to show through. Cover the canvas with paint as quickly as possible in order to get a rough impression of the finished painting. The immediacy of the wash-in is a good icebreaker between you and the empty, white canvas.

Drying Period. Allow the painting to dry at least overnight. Reds and yellows may take longer to dry than some of the blues and greens. Be patient; wait until the surface is thoroughly dry before you continue.

Block-in. Starting with the background and working forward, block in each area by mixing the value and color of each object, its shadows and light areas (Figure 4). Use opaque paint. If you must thin it, use only linseed oil in very sparing amounts. The paint must be workable yet not transparent.

Blending. Blend the edges that need softening by dabbing or stroking them with a filbert sable brush. Any brush or implement that will do the job is fine—you can even use your finger. Keep the hard edges very sharp, just as you see them in your setup.

Drying Period. Allow the painting to dry thoroughly before proceeding with the next step.

Details and Highlights. On the dry painting add the final details and highlights.

Varnish. Again allow the painting to dry thoroughly. Clean all lint from the surface with masking tape. With a 2" varnishing brush, coat the finished painting with retouch varnish to bring out color in dead or sunk-in (matte) areas. A final varnish coat can be brushed on later if you think the painting is good enough to exhibit. (This step will be discussed more fully in the demonstrations in Part Three.)

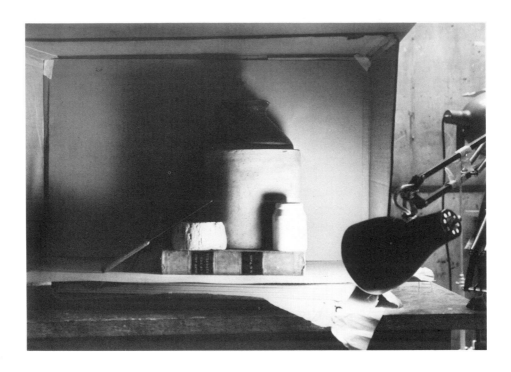

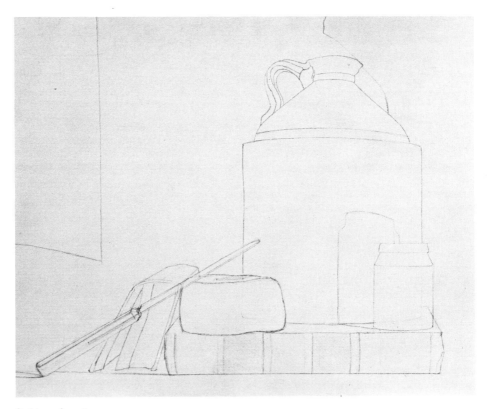

2. *Line drawing*

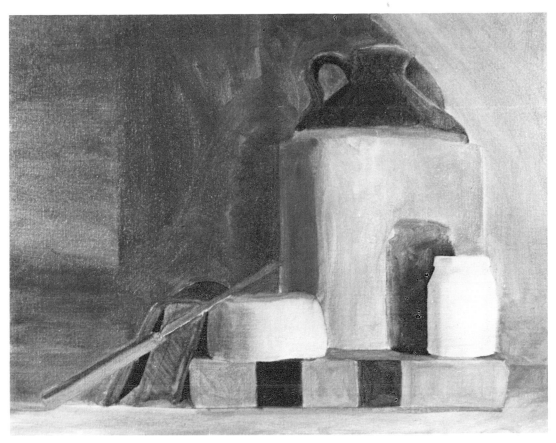

3. *Wash-in*

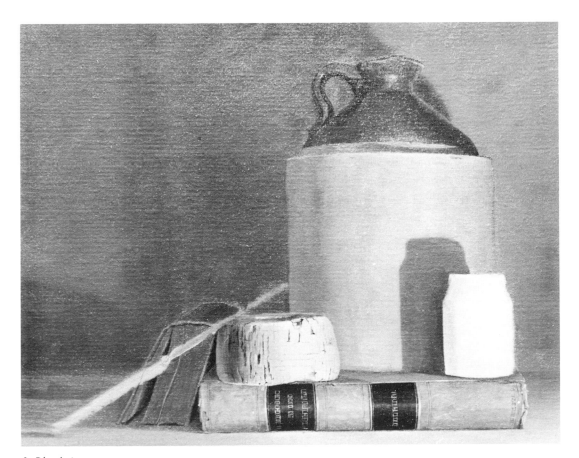

4. *Block-in*

The Blotter

EXERCISE 2 ALL-WHITE PAINTING

All-white objects against a white background present a surprising variety of values and tones. If you look at a group of white objects, you'll see that each is a slightly different color. As you study and illustrate white objects and surfaces you'll find that you use no white paint straight from the tube. Even the brightest highlights, which may seem a very pure white, will have a slight trace of yellow from the incandescent bulb of the clip-on light.

Pay special attention to the values of the shadows cast by the white objects, as there is a tendency to paint them too light. After you've carefully determined the *values* of the shadows, study their *colors*. Many of the values and colors will present problems; their variations may be extremely subtle and hard to differentiate. Approach values and colors boldly!

MATERIALS AND EQUIPMENT

Drawing supplies
Palette with full range of colors
Brushes
Canvas board, 16" x 20"
Turpentine
Linseed oil
Shadow box with extra flap to block out room lighting
Clip-on light with incandescent bulb
White construction paper
Retouch varnish
Varnishing brush, 2"

Line the shadow box with heavy white paper. Place in it any six white objects. Arrange them in a still life and light them with the clip-on light (Figure 1).

Time limit: eight hours.

Line Drawing. On the canvas board, make a line drawing of the setup. Spray it with fixative to prevent smudging.

Wash-in. Wash in the background and the local color of each white object. Mix the grays in various combinations of complementary colors, using no black. Notice that the incandescent light bulb casts a warm, slightly yellow light on the subject (Figure 2). Allow the painting to dry thoroughly.

Block-in. Carefully determine the values and colors of the shadows and highlights; with more opaque paint, block in the background and then the foreground objects (Figure 3). Notice that the values of the shadows are very dark even though all the objects are white. Blend the edges and allow the painting to dry.

Highlights. Using no white paint straight from the tube, paint the highlights. Allow the painting to dry thoroughly. Apply retouch varnish to the dry surface.

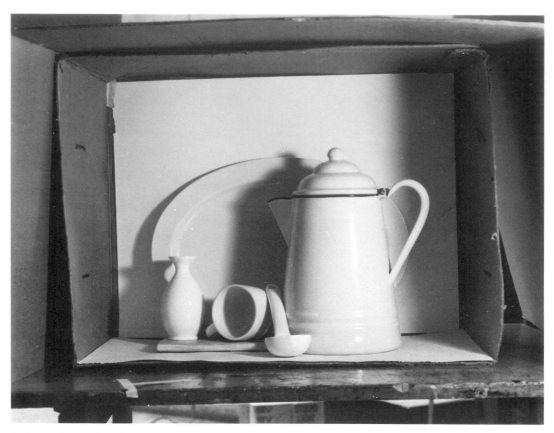

1. *Setup in shadow box*

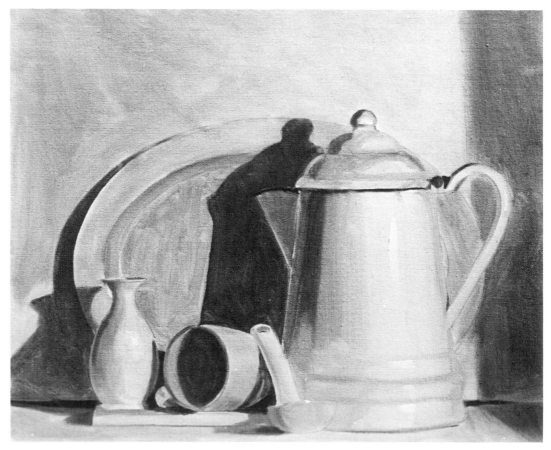

2. *Wash-in*

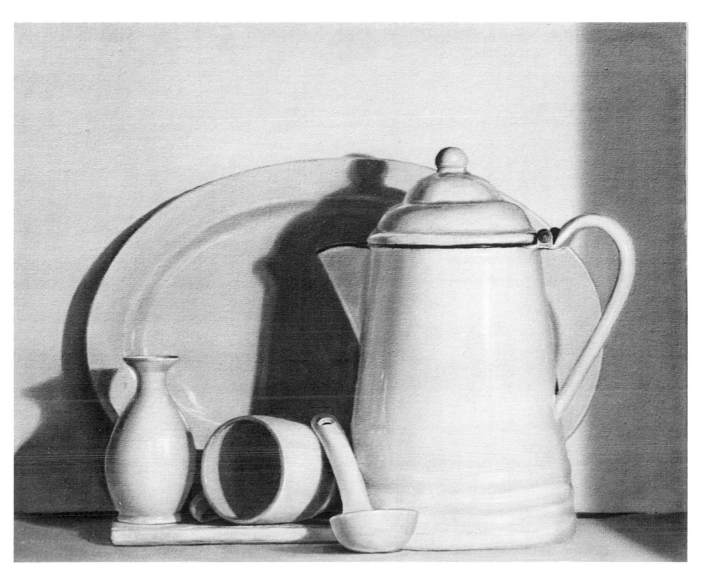

3. *Completed painting*

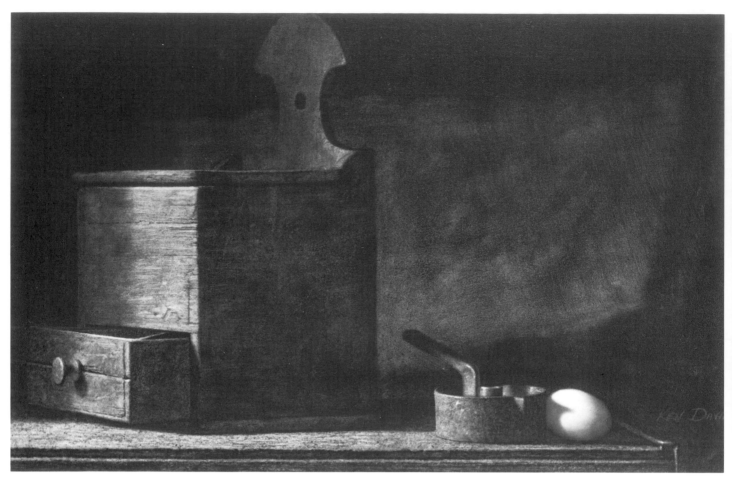

Pantry Shelf

EXERCISE 3 **ALL-BLACK PAINTING**

Black is pure only in the total absence of light. Unless you're in a completely unlighted space such as a photographic darkroom, from the moment black paint is squeezed from the tube it's no longer black. When light of any type or intensity reaches black, technically it becomes gray. Bearing this in mind, study the value and color of black by painting six black objects under an incandescent light with a minimum of black paint.

I suggest that you reduce your use of black paint for two reasons: (1) it's slow-drying; (2) it tends to produce a dirty mixture that looks as though you mixed coal dust with the paint. In place of ivory black, use a mixture of burnt umber and ultramarine blue; it's faster-drying and richer in tone. My tube of black paint was purchased 20 years ago, and there's still plenty left. The only time I use black from the tube is to paint the very darkest of darks, such as a small hole in a piece of wood or an extremely dark shadow cast on a black object.

This is a challenging experiment that will enhance your understanding of the variations in blacks.

MATERIALS AND EQUIPMENT

Drawing supplies
Palette with full range of colors
Brushes
Canvas board, 16" x 20"
Turpentine
Linseed oil
Shadow box
Clip-on light with incandescent bulb
Black construction paper
Retouch varnish
Varnishing brush, 2"

Line the shadow box with black construction paper. Place in it any six black objects. Arrange them in a still life and light them with the clip-on light (Figure 1). Although not completely black, the eight ball is used because its shiny surface reflects the other parts of the setup. You can experiment by moving the clip-on light around to find the most descriptive combination of lights and shadows in the setup before starting to work.

Time limit: eight hours.

PAINTING HINTS

When painting the setup, pay strict attention to the light areas; there's a tendency to paint them too dark. (The opposite is true with an all-white setup; dark areas are usually painted too light.)

The warm incandescant light cast on the black objects will give them a warm tint. If you choose to add yellow ochre or any other yellow or ivory tone to the black paint, a greenish mixture will result. To neutralize the greenish mixture, add cadmium red light. This is a very practical application of your knowledge of the color wheel; *green* plus its complement, *red*, is grayed or neutralized.

When dark colors dry, they have a tendency to become matte or dull. This can totally change the value of a color. To remedy this, spray or paint retouch varnish on any area that has gone "dead." The retouch varnish will revive the color to its original value. This is

an important step to repeat, since you'll need to keep relating one value to another during the painting procedure. One incorrect area left undetected can set you on the wrong course. Pay careful attention to any area that is drying; add retouch varnish to bring the values up. You can continue to paint directly over the retouch varnish, which dries very quickly.

Line Drawing. On the canvas board, make a line drawing of the setup (Figure 2). Spray it with fixative.

Wash-in. Wash in the background and objects (Figure 3). Continue to use a mixture of paint thinned with ⅔ linseed oil and ⅓ turpentine. Allow the painting to dry thoroughly.

Block-in. With opaque paint, thinned only with linseed oil, block in every value and color (Figure 4). Blend the edges and allow the painting to dry.

Highlights. Add the details and highlights, then allow to dry. Apply retouch varnish to the clean, dry surface.

1. *Setup*

2. *Line drawing*

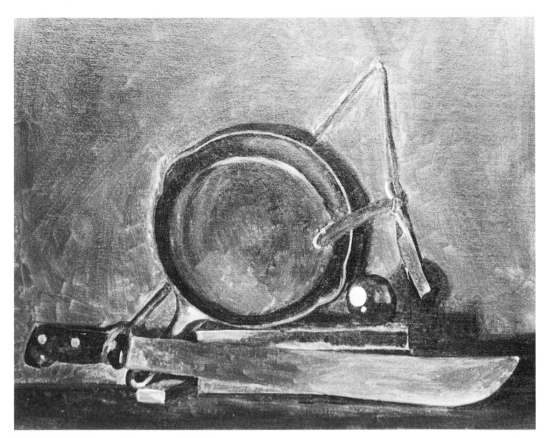

3. *Wash-in*

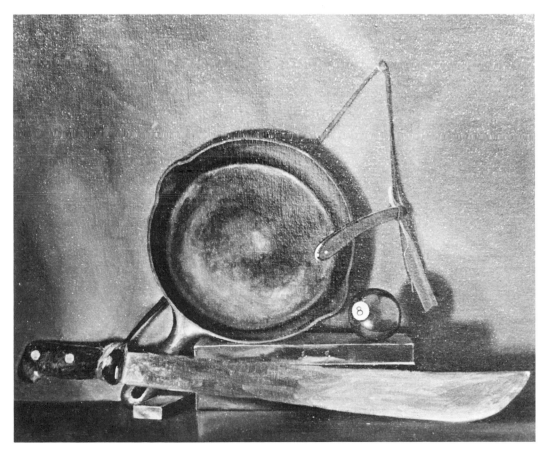

4. *Block-in*

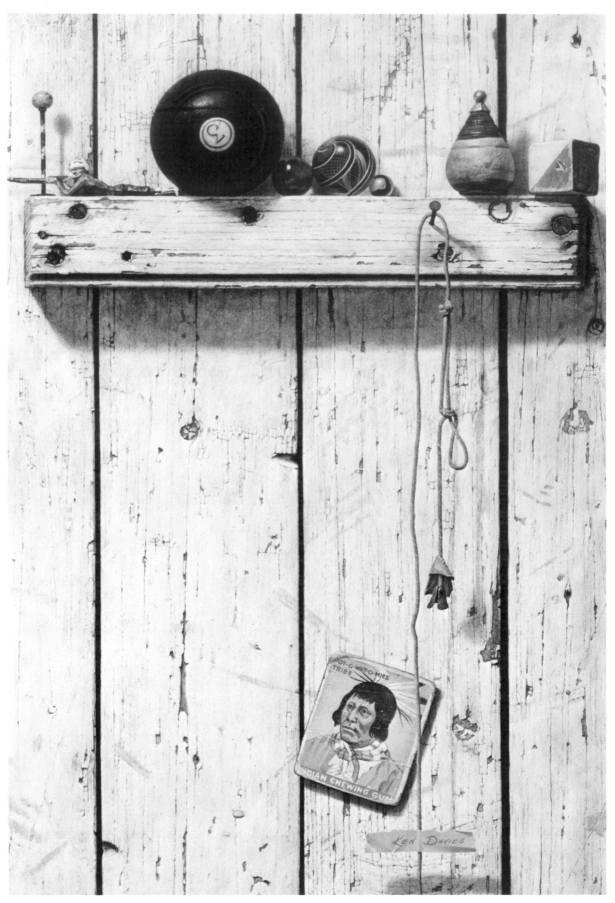

116 Chestnut Street

EXERCISE 4 ROUGH TEXTURES

Observing and learning to paint the many different textures that exist in natural and man-made objects can present a problem. How can we paint them as they truly are? It would be impossible to answer that question if we tried to cover *all* the textures that exist, so let's concentrate on only four: wood, iron, paper, and stone. They are the textures I paint most often in still life.

As you might imagine, wood, iron, paper, and stone categorically offer textures within texture. For example, wood can be either highly polished or rough and unfinished. The grain on some wood surfaces is so defined that it is actually three-dimensional. The surface of cast iron, similarly, can be either smooth or pitted and rusty.

Each of these four textures presents its own painting problem. After tackling them, it would be helpful for you to experiment with as many other textures as you can find. Leather, rough fabrics such as burlap or natural linen, or surfaces found in foliage may be interesting to you.

TEXTURES IN LIGHT AND SHADOW

When painting textured objects, you're actually painting a still life within a still life. Pinpoint an area of a rough-textured object and you can see that it's a tiny landscape of hills and valleys which are either maximized or minimized by the light cast on its surface.

An oblique angle of light cast on the object will give a pronounced texture, whereas a direct angle of light will minimize it.

In lighted areas, texture is more emphasized; in shadow areas, it is less pronounced.

Texture is most dramatically apparent in halftone areas where light glances off the object at an oblique angle.

TEXTURES IN REFLECTED LIGHT

Little or no texture is perceived in reflected light. You can observe this in nature, for example, in the light cast by the moon. Moonlight, you may recall, is reflected light. In moonlight there is little definition of the earth's texture. The same is true of the reflected light in your still life setup. Find the areas of reflected light and observe how little texture is apparent. Now compare the textures in the reflected light areas to those in the direct light areas. Notice that texture is minimized under reflected light and maximized under direct light.

Critical virtues for achieving realistic results in sharp focus still life painting are patience and fidelity. Careless, hurried work almost invariably results in sloppy, amateurish paintings. Close attention to each textured area and faithful rendering separate the professional from the amateur.

MATERIALS AND EQUIPMENT

Drawing supplies
Palette with full range of colors
Brushes
Canvas board, 16" x 20"
Turpentine
Linseed oil
Shadow box
Clip-on light with incandescent bulb
Retouch varnish
Varnishing brush, 2"

Set up a still life arrangement, using wood, iron, paper, and stone objects. Attempt to find rough-grained wood and pitted iron. The shadow box can be either lined or unlined. Experiment with the angle of the light on the setup in order to heighten textures. You can bring out the textures of the objects by placing the clip-on light at an oblique angle to create deep shadows (Figure 1). The nail that secures the piece of wood to the back wall of the shadow box will be painted as part of the still life. The upper left corner of the piece of paper has been bent forward to create an interesting shadow; the right side of the paper is folded forward to create a large shadow area on the side of the cast-iron pot. The rock is carefully arranged so its lighted side shows up against the shadow side of the pot.

Time limit: eight hours

Line Drawing. On the canvas board, make a line drawing of the setup (Figure 2). Spray with fixative.

Wash-in. Wash in the background and local color of each object (Figure 3). At this stage none of the textures has yet been suggested. Allow to dry thoroughly.

Block-in. Block in the values and colors of the background and objects. Now you can begin to suggest the textures of the objects. Start to paint the wood grain and the stone by working directly into the wet paint with a small sable brush. Suggest the pitted areas of the cast-iron object by stippling or dabbing at the wet surface with a round bristle brush. If there are wrinkles or folds in the paper object, paint in only the major areas. Don't attempt to render complete details while the painting is wet. Complete all the major textural shapes in this block-in stage and leave the details and highlights for later. Allow the painting to dry thoroughly.

Completing the Painting. Use a small sable brush to carefully paint the details. Each line of the wood grain must be painted individually and literally. The same is true for the stone and iron objects. The success of the reality you achieve will be in direct proportion to the amount of time devoted to painting these textural details (Figure 4). After allowing the painting to dry thoroughly, apply retouch varnish.

1. *Setup*

2. *Line drawing*

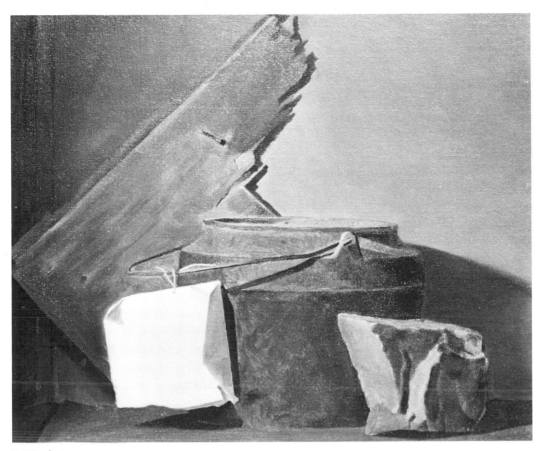

3. *Wash-in*

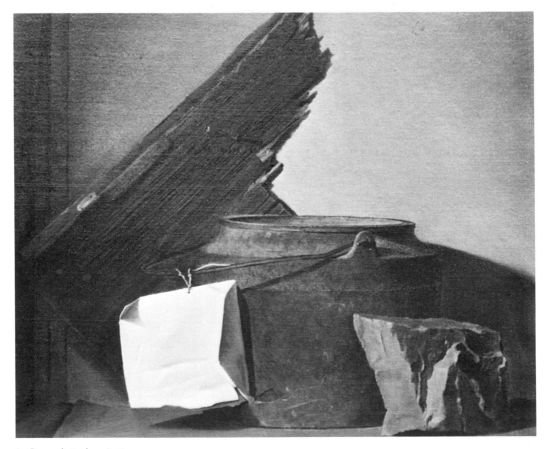

4. *Completed painting*

Kid's Things

EXERCISE 5 SMOOTH TEXTURES

Most beginning painters (and many experienced painters, too) are baffled when faced with the transparency of glass and the highlights and reflections of metallic objects. They are apt to ask themselves: "How do I transform all this gloppy oil paint into a smooth, shiny surface?" It's one of the easiest things for a painter to do—and I'll prove it!

The first thing for you to do is convince yourself that the problem is all in your mind. Now, turn off that electric sign in your head that says "glass" or "metal," and start thinking "shape, value, color." Look at the reflection of the light on the glass vase in your setup: the reflection has its own *shape* contained within the outline of the vase, it has its own *value* in relation to all the other values you see, and it has its own *color*. All you have to do is draw the shape and match its color and value.

MATERIALS AND EQUIPMENT

Drawing supplies
Palette spread with full range of colors
Brushes
Canvas board, 16" x 20"
Turpentine
Linseed oil
Shadow box
Clip-on light
Retouch varnish and brush

In this exercise, I recommend that you use one object from four different categories to give yourself the chance to solve most of the problems that will arise in painting glass and metal surfaces. The objects should vary in size. They should be absolutely smooth rather than cut, carved, or embossed. The four objects should include a clear glass object, a colored glass object, a silver-colored object, and a gold-colored object. You will also need a shadow box lined with colored or neutral fabric or paper and a clip-on light with an incandescent bulb.

Time limit: eight hours.

Setup. Place the four objects in the shadow box in a still life arrangement. Light the setup with the clip-on light, maximizing shadows and highlights.

Line Drawing. Make an outline drawing of the still life setup (Figure 1). Draw the outlines of the major shapes of the reflections and highlights *within* each object. These inside shapes make the painted objects look realistically like glass and metal. Smooth objects naturally reflect shapes of other objects close to them, much like a mirror, and if those reflections are neglected, the essence of the surface is lost. Spray the drawing with fixative to prevent smudging as you start to paint.

Wash-in. Wash in the background and local color of each object and of the shapes of the reflections and highlights within them (Figure 2). Even now the effect of shiny glass and metal is evident. Allow the painting to dry thoroughly.

Block-in. Carefully determine the value and color of each outlined shape. Match the color of each shape (as you did on the Color Matching Chart, Project 4) and block the color into the proper area of the drawing (Figure 3).

Completing the Painting. Determine the relative softness or hardness and blend each edge. Then add the highlights. You'll obtain the most realistic effect by paying careful attention to details.

Now, for the first time, you're allowed to think "glass" or "metal." And, if the above procedure has been followed faithfully, I guarantee that your opaque, soft-textured oil paint will now look like transparent glass and shiny metal.

1. *Line drawing*

2. *Wash in*

3. *Painting almost completed*

From Circuit Avenue

EXERCISE 6 **REFLECTED LIGHT**

Reflected light originates from a main light source, deflects off a surface, and bounces into a shadow area. Usually, reflected light is of a darker value than direct light. Its color is partially determined by the reflecting surface.

In this exercise we want to observe and study the intensity, color, and value of reflected light. A dramatic example that I use is to hold a bright green or blue piece of paper close to my face. Standing in front of a mirror, I aim a strong light at the right side of my face while holding the paper to the left side. I allow the light beam to illuminate the paper at the same time that it illuminates my face. The shadow side of my face shows the bright color of the reflected light.

Snow also provides good examples of reflected light. The shadows on snow reflect the light of the sky; shadows are blue if the sky is blue, gray if the sky is gray.

MATERIALS AND EQUIPMENT

Drawing supplies
Palette with full range of colors
Brushes
Canvas board, 16" x 20"
Turpentine
Linseed oil
Shadow box
Clip-on light
One piece each of red, yellow, and blue fabric
A smooth white ball
Retouch varnish and brush

Line the back wall, floor, and side of the shadow box with red, yellow, and blue fabric, respectively, draping the fabric in folds. Place the white ball in the center of the shadow box. Light the setup with the clip-on light, aimed from the left at approximately a 20° angle, and observe what has happened (Figure 1). The white ball reflects the color of the fabric. The reflected light comes into play on the folds of the draped fabric and influences the colors of various parts of the ball. Reflected light is often not as light in value as it appears. In order to determine accurate values, compare the value of the light side of the ball with the value of the shadow side.

Time limit: eight hours.

Line Drawing. Make a line drawing of the setup on the canvas board (Figure 2). Spray with fixative.

Wash-in. Wash in the background value and color and the white ball (Figure 3). Allow to dry.

Block-in. Block in the lights and shadows of the draped folds and the white ball. Allow to dry.

Completing the Painting. Paint the highlights. Allow to dry. Then apply retouch varnish.

1. *Setup*

2. *Line drawing*

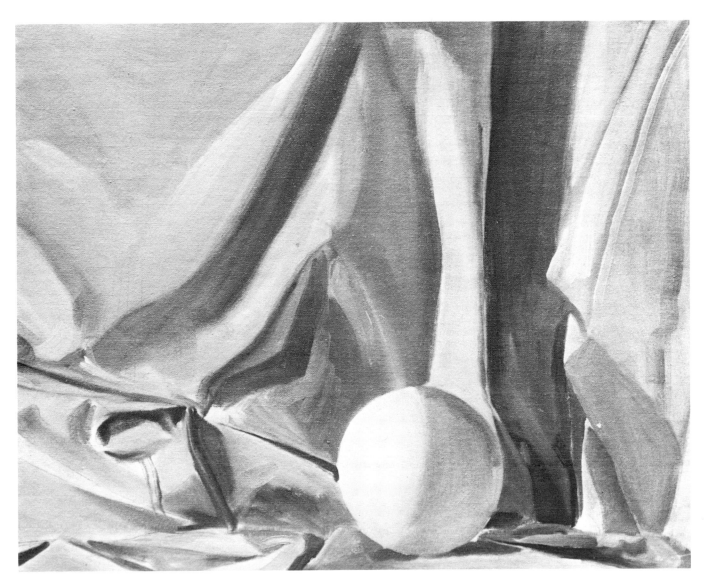

3. *Wash-in*

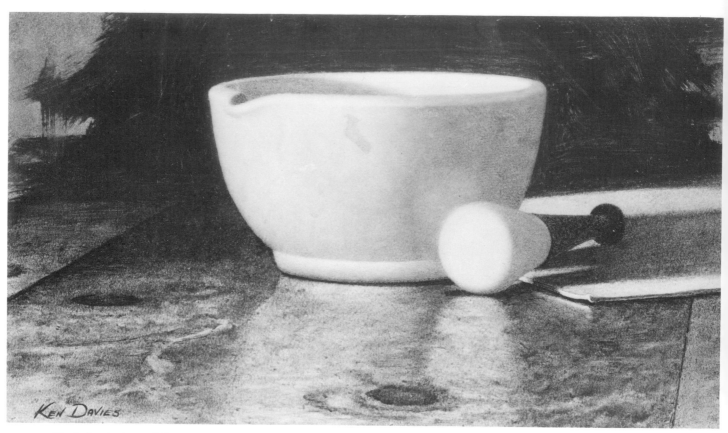

Study for Light and Props

EXERCISE 7 SPEED PAINTING

Hesitation in judging shapes, values, and colors, and trial-and-error color mixing are generally frustrating to the inexperienced painter. Decision-making of this sort during the painting procedure can be accelerated by: (1) imposing shorter time limits; (2) reducing the size of the painting area; and (3) using the direct painting method.

Your canvas board will be divided into quarters for this challenging experiment. In each quarter, you'll complete a mini-still life painting in a three-hour time limit. Small objects should be used for the setup, for example, spools of thread, tiny bottles, or children's blocks. Use the same objects in all four paintings, but for the sake of variety rearrange them in each setup. Use the direct painting method: determine the value and color of an area, mix the corresponding color, put it down, and leave it alone. There won't be time to change it. The wash-in, block-in, and drying periods are eliminated to speed up the procedure.

At first you may not be able to complete a painting in three hours, but at least attempt to complete all but the sharp details. Certainly all raw canvas should be covered.

If you're truly conscientious and can resist cheating on the time limit I've prescribed, you'll find that just the attempt at these four little paintings will considerably develop your ability to judge shapes, values, and colors more quickly and accurately.

MATERIALS AND EQUIPMENT

Drawing supplies
Palette with full range of colors
Brushes
Canvas board, 16" x 20"
Turpentine
Linseed oil
Shadow box
Clip-on light
Six small objects

Place the six small objects in an unlined shadow box. Light the setup with the clip-on light and incandescent bulb.

Time limit: three hours for each painting.

Rough Sketch. With a pencil and ruler, divide the canvas board into quarters. In the first quarter, make a quick, rough pencil sketch of the setup (Figure 1). Spray it with fixative.

Direct Painting. Apply the paint directly to the background areas (Figure 2).

Completing the Painting. In three hours complete as much as possible of the setup. You should try to cover all raw canvas, complete all objects, and suggest highlights (Figure 3).

Rough Sketch of the Second Quarter. Rearrange the same six objects in the shadow box and sketch the setup (Figure 4).

Direct Painting. Paint the second quarter as you did the first, being careful to accurately portray shapes and values (Figure 5). Complete this painting in three hours also.

Painting the Other Quarters. Rearrange the setup, sketch, and directly paint the remaining two quarters of the canvas as you did the first two (Figure 6).

Note: If you were able to complete the fourth painting, don't feel too sure of success until you've completed Exercise 8.

1. *Rough sketch of first quarter*

2. *Background directly painted*

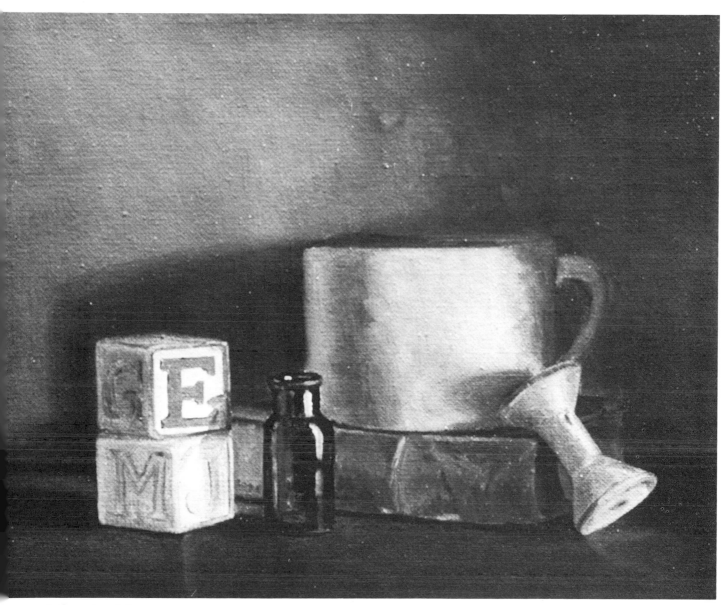

3. *Completed first quarter*

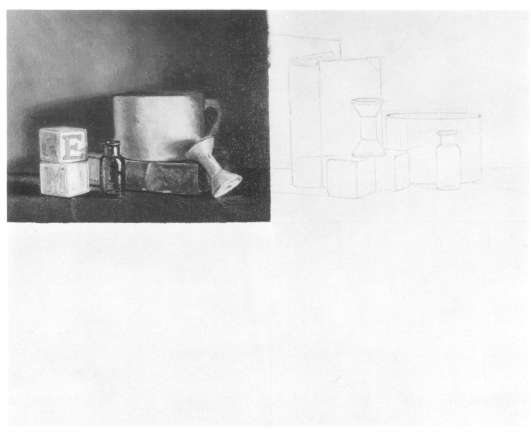

4. *Rough sketch of second quarter*

5. *Completed second quarter*

6. *All four quarters completed*

Coffee Grinder

EXERCISE 8 SPEED PAINTING

Insure the speed with which you make painting decisions about value, color, and shape by completing four more speed paintings. Again your canvas will be divided into quarters. In the first setup use six small objects; in the second use eight; in the third use ten; and in the fourth use 12 objects. As you see, the addition of two more objects to each speed painting increases the pressure on the painter, who must make his color and value choices at a much faster rate each time. The time limit for each painting is three hours.

Contrary to what you may think, this exercise is not designed merely to drive the student mad, but to train nimble eye-hand coordination. Good luck.

MATERIALS AND EQUIPMENT

Drawing supplies
Palette with full range of colors
Brushes
Canvas board, 16" x 20"
Turpentine
Linseed oil
Shadow box
Clip-on light
Twelve small still life objects

For each speed painting arrange the small objects in an unlined shadow box. Light the setup with the clip-on light and incandescent bulb. Divide the canvas into quarters with a pencil and ruler.

Time limit: three hours for each painting.

Painting the First Quarter. In the first quarter, arrange six objects in the shadow box, light the setup, make a quick rough sketch, and complete the painting in three hours as you did in Exercise 7.

Rough Sketch of the Second Quarter. Rearrange the setup, this time using eight objects. Make a rough sketch of this setup in the second quarter (Figure 1).

Direct Painting. Paint in the background areas and begin to paint the details of the foreground shapes, blending the soft edges (Figure 2).

Completing the Painting. Complete the painting in three hours, adding highlights if possible (Figure 3).

Painting the Other Quarters. In the remaining quarters, complete speed paintings using 10 and then 12 objects. Follow the procedure outlined above (Figures 4, 5, and 6).

1. *Rough sketch of second quarter*

2. *Direct painting*

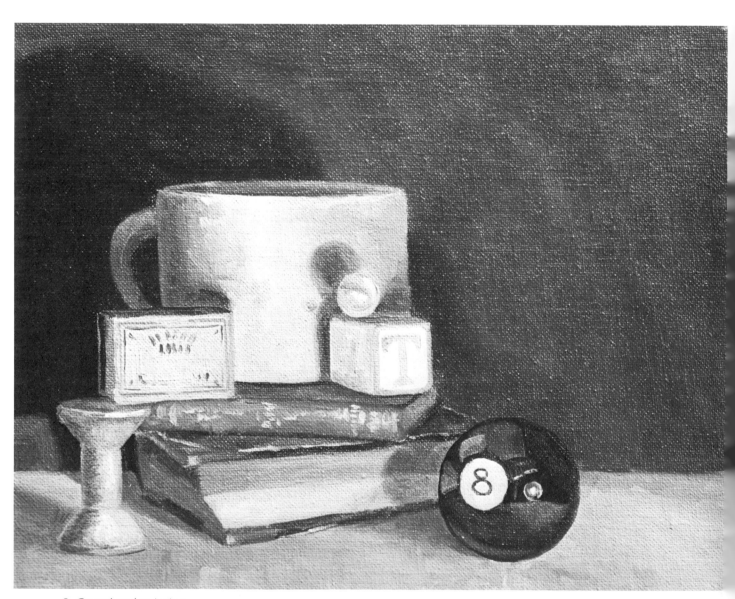

3. *Completed painting*

4. *Rough sketch of third quarter*

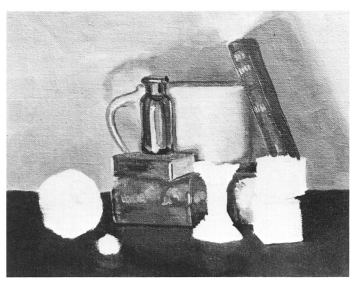

5. *Direct painting*

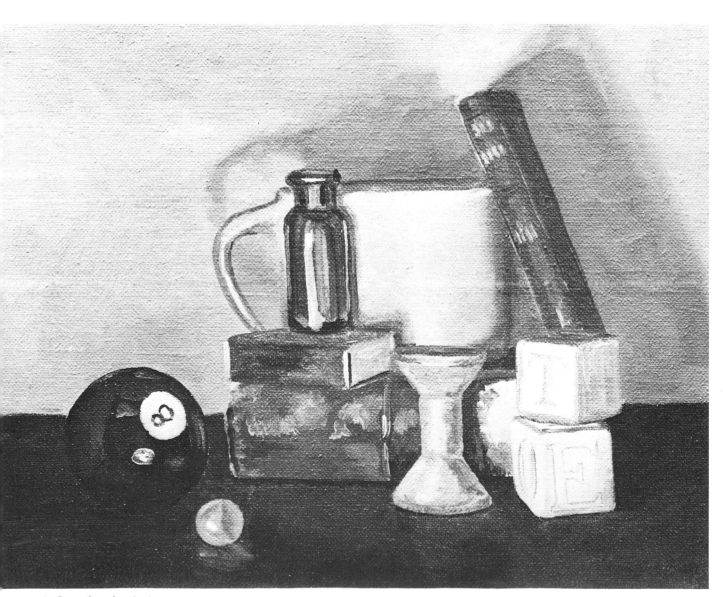

6. *Completed painting*

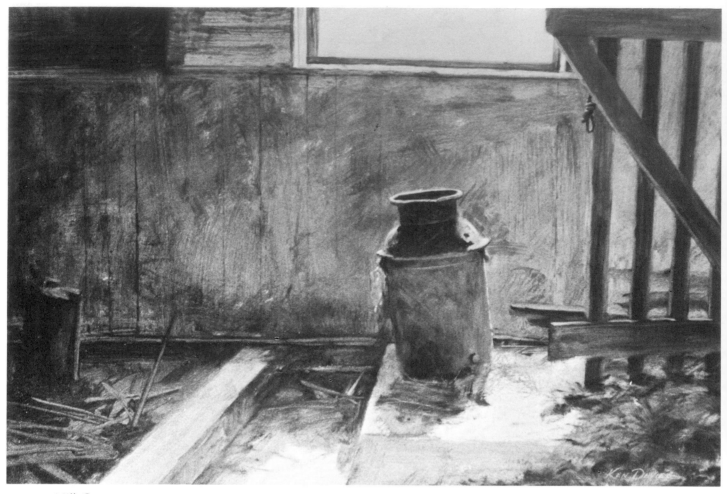

Milk Can

EXERCISE 9 MONOCHROME WET-INTO-WET

In previous exercises the wash-in and block-in stages were separated by long drying periods. Each time you applied a new color to the dry surface, you could anticipate the need to blend some edges and soften others.

By eliminating the drying periods between the wash-in and the block-in, softer edges can be achieved. The wash-in will still be wet while you work more opaque paint over it (block in). This is called working "wet-into-wet." Many still life painters prefer this method when they want to avoid hard edges.

Working wet-into-wet is a looser form of painting, and I think you'll find it an exciting change of pace. To lessen the complication of working with too many colors at the outset of this new method, use objects of the same general color in your setup.

MATERIALS AND EQUIPMENT

Drawing supplies
Palette with full range of colors
Brushes
Canvas board, 16" x 20"
Turpentine
Linseed oil
Shadow box
Clip-on light
Retouch varnish and brush

For the monochrome wet-into-wet painting, choose any six objects of the same general color. Be certain that the background color in the shadow box is in the same color range. The earthenware jug, brown egg, rusty horseshoe, old scythe, and book are all warm earth tones (Figure 1). Here the natural corrugated board of the shadow box works as a background. However, if you choose, for example, a blue monochromatic scheme, line the shadow box with a shade of blue.

Time limit: eight hours.

Setup. Place the six objects in the shadow box. Light the setup with the clip-on light (Figure 1).

Line Drawing. Make a line drawing of the setup on canvas board. Spray it with fixative.

Color Wash. Determine the approximate middle color value of the setup. Mix that color thinned with turpentine; the pigment must be transparent. Then brush the thinned color over the entire canvas. The drawing should be visible through the paint (Figure 2).

Block-in. While the wash is still wet, start painting with opaque tones. Block in the background, then the foreground. Block the objects in the setup directly into the wet paint, trying to get as close to the correct values and colors as you can while the paint is wet (Figure 3). Allow the painting to dry thoroughly.

Sharpening the Painting. Start to sharpen some areas of the painting, while leaving other areas in soft focus. A beautiful effect can be created, for instance, by sharpening the focus of the center of interest while all other areas remain soft, or you may want to sharpen just one object and leave the other parts of the setup unfinished.

When you're satisfied with the soft- and hard-edged effects, allow the painting to dry. Then brush on retouch varnish.

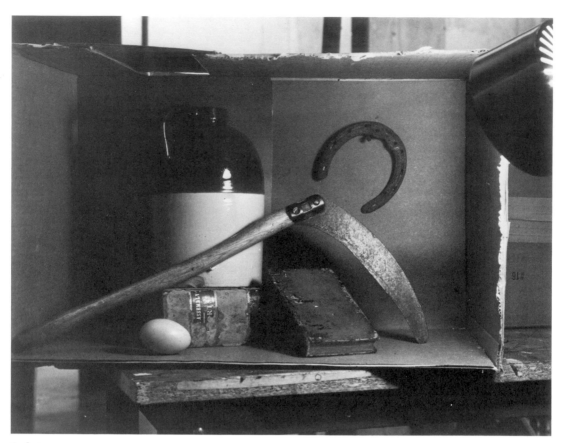

1. *Setup*

2. *Color wash*

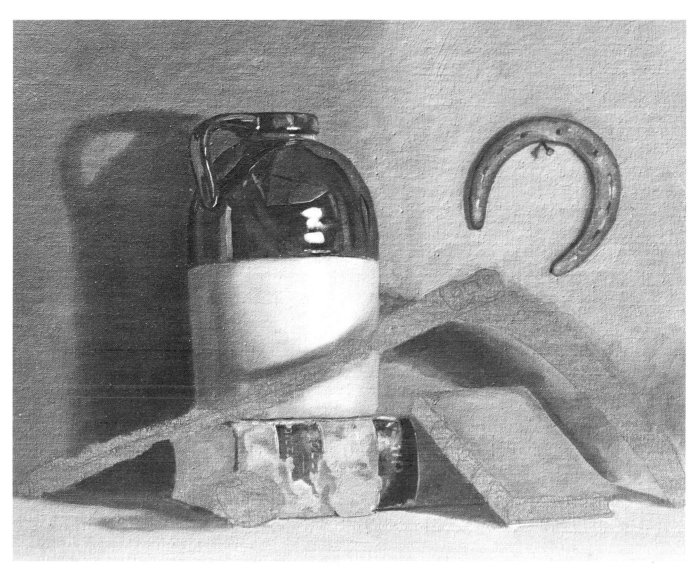

3. *Block-in partially completed*

Williamsburg Coffee Grinder

EXERCISE 10 **DRAWING WITH A BRUSH**

If you're interested in a looser style, making your initial drawing of the setup with a brush on the canvas board can help you move in that direction. Drawing with a brush will give you more room for expression. However, in terms of perspective, your drawing should be almost as precise as when you were drawing with a pencil, although perhaps not as detailed. In this case, the drawing can and should be corrected during each painting stage rather than perfected at the start.

Test your skill in this exercise by drawing on the canvas board with a brush. It will give you the experience necessary for a softer-focus style of painting.

MATERIALS AND EQUIPMENT

Palette with full range of colors
Turpentine
Linseed oil
Brushes, including a No. 6 round sable
Canvas board, 16" x 20"
Turpentine
Linseed oil
Shadow box
Clip-on light
Retouch varnish and brush

Choose any five objects. In the beginning it is best to choose objects with uncomplicated silhouettes and little or no decoration. Arrange them in the shadow box. Light the setup with the clip-on light (Figure 1).

Time limit: eight hours.

Brush Drawing. Make a drawing of the setup on the canvas board, using the No. 6 round sable brush. Use paint of the color predominant in the setup thinned with turpentine. Although the drawing should be made in correct perspective, it isn't necessary to refine it in this stage (Figure 2). The thinned paint will dry quickly.

Wash-in. Thin your paint with turpentine and linseed oil and wash in the background, the local color of each object, and the shadows. Correct and refine the drawing at this stage (Figure 3). Allow the painting to dry thoroughly.

Block-in. Block in the background color and the color of each object in the setup with opaque paint (Figure 4).

Completing the Painting. Refine the drawing again by adding all details and highlights. Allow the painting to dry, then paint with retouch varnish.

1. *Setup*

2. *Brush drawing*

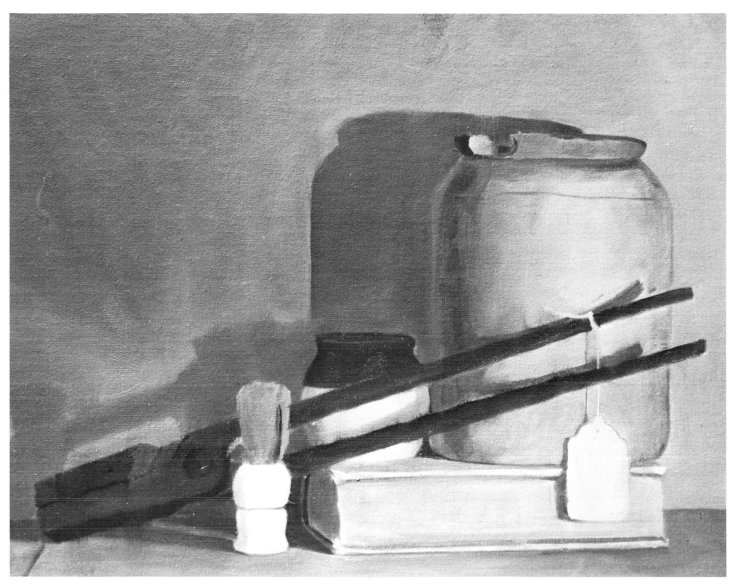

3. *Wash-in*

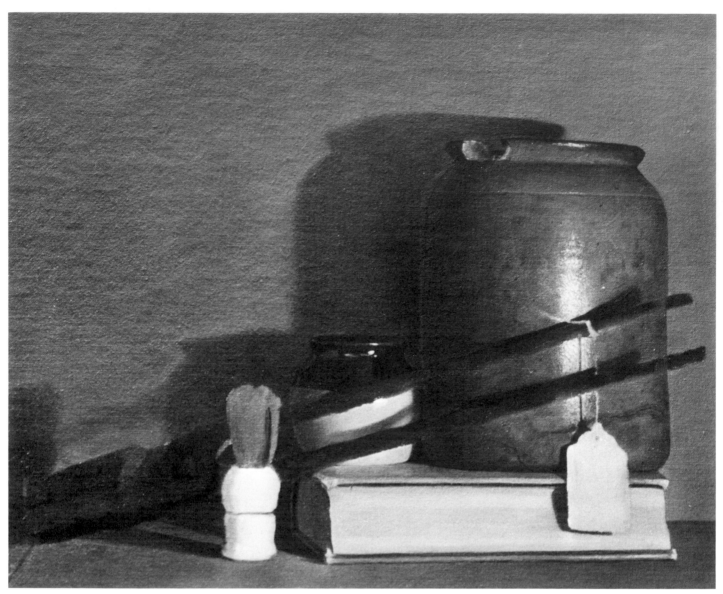

4. *Block-in*

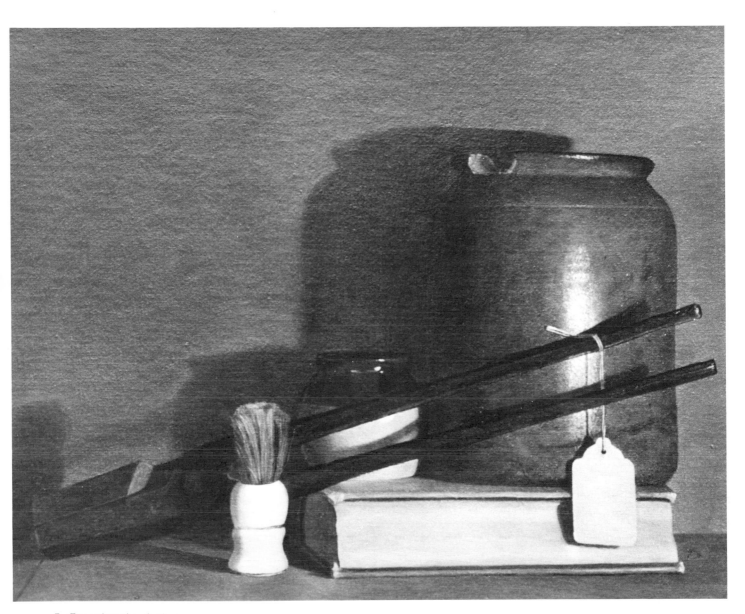

5. Completed painting

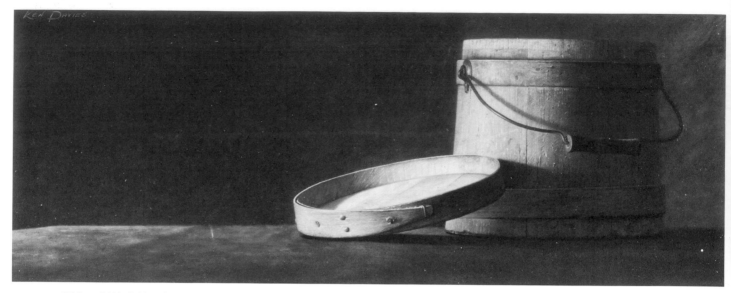

Old and Well Used

EXERCISE 11 **STILL LIFE UNDER RED LIGHT**

The color of light is fascinating to study. Let's approach this exercise by observing the effect of a colored light source on the local color of objects. Up to this point, we've been using an ordinary incandescant bulb to light the subject. The incandescent bulb, as you will have observed, gives a slightly yellowish tint to the objects, and this is how they are often normally seen. Now replace the incandescent bulb with a red one. You'll see that dramatic color changes occur as the red light shines on an area. Think of your setup as a stage set where performers will appear; you've just cast a red spotlight on the set. Under the red spotlight, whites appear a glowing red, whereas green objects turn gray and red objects glow with more insensity. Place blue, green, and yellow objects under the red spotlight and observe the color changes that occur.

It's said that human color perception is diminishing. If this is true, perhaps the remedy for the artist is to try harder to see color and to understand its nature. The study of the color of light and the color of paint is complicated and compelling. This exercise gives you the opportunity to make your own discoveries about our perception of color, a subject over which scientists have been at odds for centuries.

MATERIALS AND EQUIPMENT

Drawing supplies
Palette with full range of colors
Turpentine
Linseed oil
Brushes
Canvas board, 16" x 20"
Shadow box
Clip-on light and red bulb
Retouch varnish and brush

Choose five or six objects of any color and arrange them in the shadow box (Figure 1). Observe the setup under incandescent light. Now change the bulb to red. Notice the dramatic difference.

Time limit: eight hours.

Line Drawing. Make a line drawing of the setup on the canvas board. Be sure to include the outlines of all the shadows and details (Figure 2). Spray the drawing with fixative.

Wash-in. Wash in the background and local color of each object (Figure 3). Allow the painting to dry.

Block-in. Block in the entire setup (Figure 4). Allow to dry. Add highlights and details, then paint with retouch varnish.

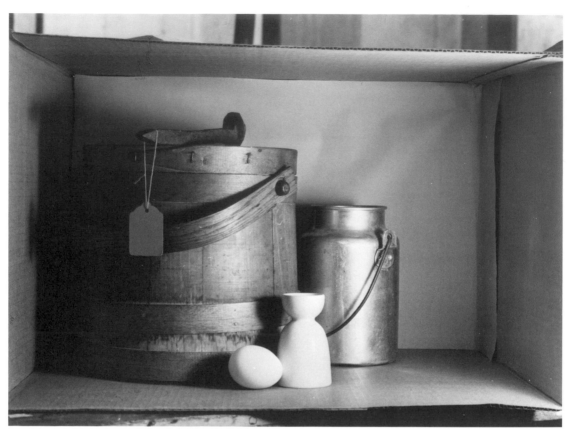

1. *Setup*

2. *Line drawing*

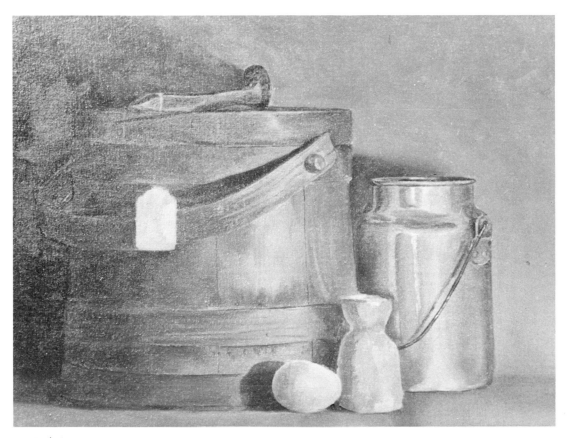

3. *Wash-in*

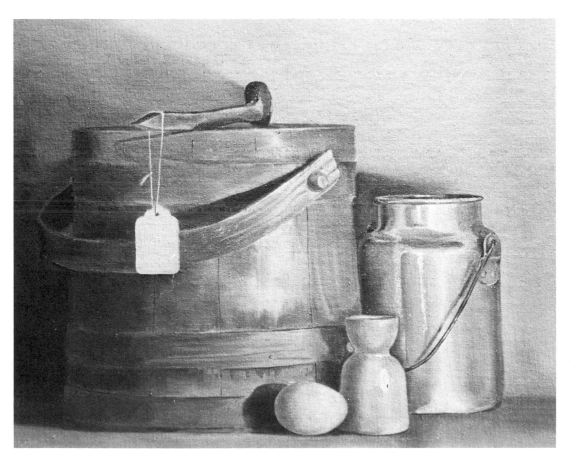

4. *Block-in*

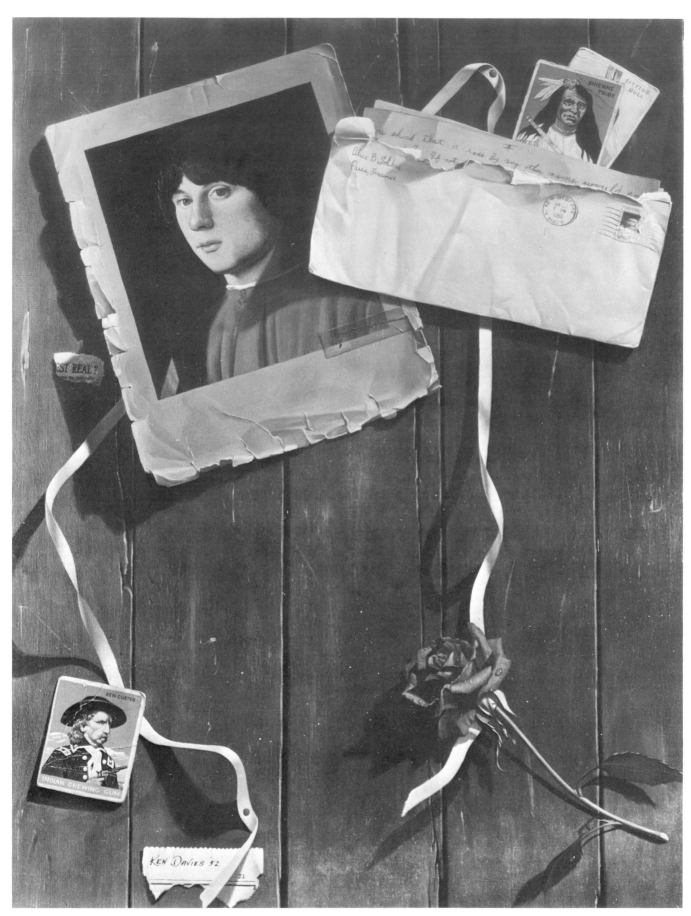

Is a Rose a Rose?

EXERCISE 12 **STILL LIFE UNDER GREEN LIGHT**

I hope that by completing Exercise 11 your color perception has been heightened. Now we will study the effect of a green light bulb. This time your setup will be composed of every color on the basic color wheel with the addition of a white and a black object. This isn't as complicated as it may seem. The exercise simply carries you one step further in the study of color and light. By now you know that you can change the color of an object by changing the color of the light shining on it. Or that you can increase the intensity of a color if the light source and the object are the same color.

Playing with color and light will help you to investigate the physics of light. You may find that the most intense colors you can create with light are *so* intense that they are impossible to reproduce with pigment. Don't expect a perfect match in such a case. Do try all sorts of combinations of your own by shining different colored lights on objects of varied colors. You'll be amazed at some of the results.

At some time in the future, you may want to use this newly gained knowledge to control the colors of your setup by lighting part of it with natural and part with colored light.

Color information of different kinds is also practical for professional illustrators, for example in an assignment to paint a stage set lit by colored spotlights, or in an interior of a room with light coming through a stained glass window. Color study is particularly valuable to the artist, because often a painting or illustration must be invented in the studio.

MATERIALS AND EQUIPMENT

Drawing supplies
Palette with full range of colors
Turpentine
Linseed oil
Brushes
Canvas board, 16" x 20"
Eight colored objects, one each of: red, blue, yellow, green, violet, orange, black, and
 white
Shadow box
Clip-on light with green bulb
Colored construction papers (four of the above objects can be torn pieces of construc-
 tion paper)
Retouch varnish and brush

Tack four different colors of construction paper to the back wall of the shadow box. Place the black object, the white object, and the two remaining colored objects in the shadow box. Light the setup with the clip-on light containing a green bulb (Figure 1).

Time limit: eight hours.

Line Drawing. Make a line drawing of the setup on the canvas board (Figure 2). Spray the drawing with fixative.

Wash-in. Wash in the background and local color of each object (Figure 3). Allow to dry.

Block-in. Block in the background and local color of the objects, correcting the color as you go. Begin some of the details (Figure 4). Allow to dry.

Completing the Painting. Add details and highlights. Allow to dry thoroughly. Then you can add minute details, such as the torn binding of the book and the highlights on the billiard ball (Figure 5). Allow to dry and then paint on retouch varnish.

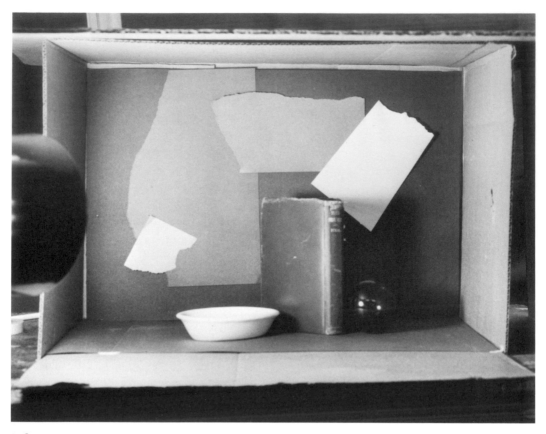

1. *Setup*

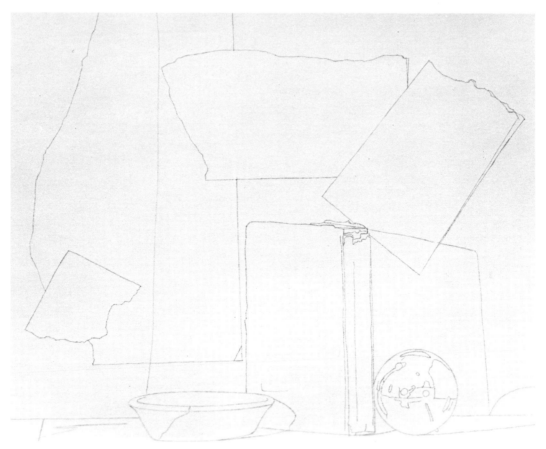

2. *Line drawing*

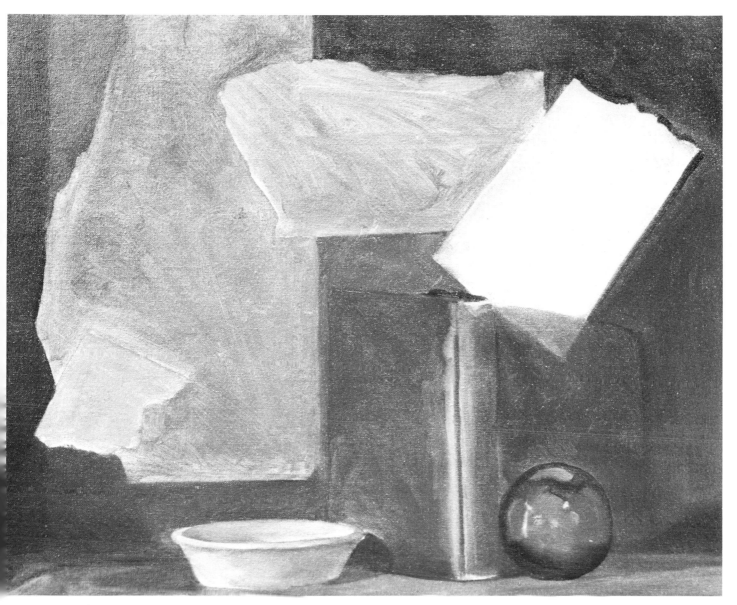

3. *Wash-in*

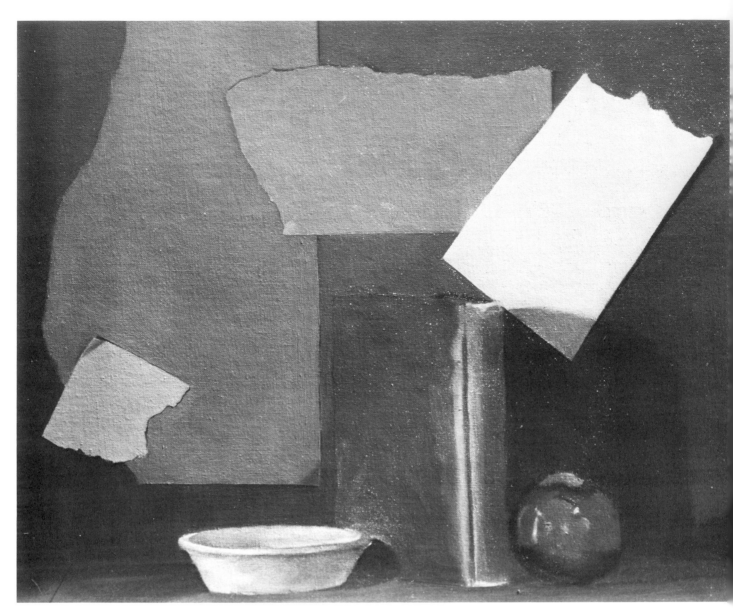

4. *Block-in*

5. *Completed painting*

Red and White

EXERCISE 13 GLAZING AND SCUMBLING

The first two parts of this book are designed to give you the practical steps necessary to learning the techniques of direct painting. In direct painting, you're concentrating on achieving the right values and colors just as they are, from the very start to the finish of a painting. The paintings you produce from these projects and exercises are not intended to be exhibition quality but merely a series of practice pieces used to learn new skills and sharpen old ones.

This exercise marks a transition to a new plane of endeavor for the painter, one in which important exhibit-worthy paintings may be produced. Here we'll investigate two painting methods that have not been discussed up to now, glazing and scumbling. Glazing is a method by which one layer of paint is applied over another. The undercoat must be thoroughly dry before the glaze is brushed over it. A glaze is usually thinned paint of a dark value painted over a lighter value. The layer beneath the glaze shows through to give a luminous quality. It's the transparency of the glaze that makes the difference between the directly painted shadow and the glazed shadow.

The advantage of glazing in sharp focus realistic painting is most evident when applied to shadows and the details that fall within them. Glazed shadows appear more realistic than directly painted ones. They're convincing enough to give the feeling that one can reach deep into them. The details are minimized in glazed areas and seem mysterious.

The scumble, or scumbling technique, is a method of applying an opaque light-colored paint mixture on a dry layer of dark paint, just the opposite of glazing. In scumbling, fairly thick paint is either dry-brushed or applied in normal fashion to the surface. Scumbling gives the surface of the painting a sense of immediacy. Textures are maximized, giving the impression that the surface is real enough to touch.

The general rule I make is that *shadows are glazed down* and *light areas are scumbled.*

MATERIALS AND EQUIPMENT

Drawing supplies
Palette with full range of colors
Brushes
Canvas board, 16" x 20"
Turpentine
Linseed oil
Shadow box
Clip-on light
Still life objects
Masking tape
Retouch varnish and brush

Set up a still life in the shadow box using relatively simple objects. Light the setup with the clip-on light and incandescent bulb.

Time limit: eight hours.

Line Drawing. Make a line drawing of the setup on the canvas board. Spray it with fixative.

Wash-in. With transparent paint (thinned with a mixture of ⅔ linseed oil and ⅓ turpentine), wash in the background and local color of each object.

Block-in. In preparation for glazing, the block-in procedure is slightly different from before. Paint the shadows lighter than they appear in the setup. They will later be glazed down to the correct value.

Paint the light areas slightly darker than they appear in the setup. They will later be scumbled with light paint and brought up to the correct value.

Paint the details in the light areas. If some of the details in light areas continue into shadow areas, paint them a darker value in the shadow area yet slightly lighter than they actually are. At this stage allow the painting to dry thoroughly.

Glazing. All dust must be removed before glazing, otherwise the glazed area will appear gritty rather than smooth. Use masking tape to carefully lift all loose lint or dust from the surface.

Glaze all shadow areas as follows: Mix a transparent dark wash. With a filbert or flat brush, wash the color over the shadow areas. When you're glazing a surface that must appear round, find the area where the shadows blend into light areas. At those points feather out the paint with quick movements of the brush (Figure 5).

The transparent paint used for the wash must be neither too thin nor too opaque. Experience will eventually tell you how to reach the right consistency. When in doubt, make the wash on the thin side rather than too opaque. When a thin glaze has dried another darker layer can be added, but if a glaze that is too opaque is used it is much more difficult to correct.

Daubing. After the glaze is applied, it will look streaky and the details will be partially obliterated. To correct this, shape part of an old tee shirt into a dauber (Figure 6). Lift all loose lint and dust from the dauber with masking tape. Pat and blot the wet glaze until it is smooth and blended. The value of the glaze will now be considerably lighter (Figure 7).

Scumbling. Scumble the highlights and light areas with opaque paint of light value and add minute details. When dry, coat with retouch varnish. Glazing and scumbling will be illustrated further in the demonstrations in Part Three.

1. *Setup*

2. *Line drawing*

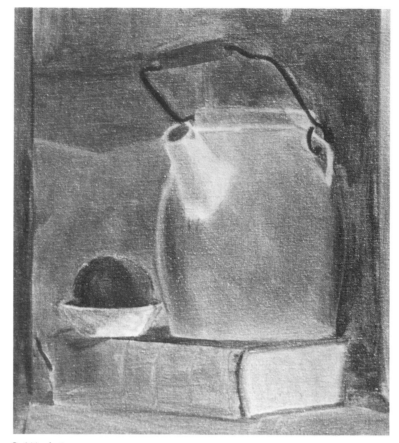

3. *Wash-in*

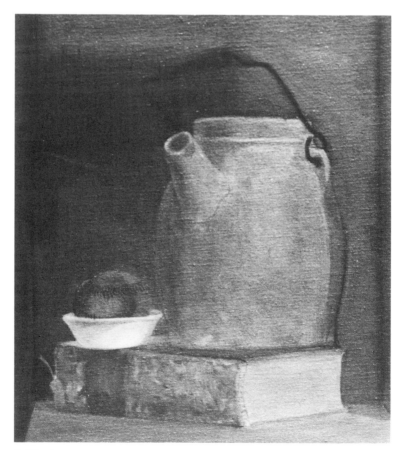

4. *Glazing*

5. *Glaze application*

6. *Tee shirt used as a dauber*

7. *Glazed area after daubing*

8. *Detail of block-in area before glazing*

9. *Detail after glazing and scumbling*

A Commemorative *(Opposite page). In 1972 I was commissioned by the United States Postal Service to design the Pharmacy Stamp. Later I thought it would be amusing to paint a trompe l'oeil that would include the stamp. The mailbox which provides the setting was given to me by a student. The composition fell together quite easily, but painting the small postage stamp life size in oils was one of the most grueling jobs I've ever faced: for the first time in my career I had to use a magnifying glass while painting.*

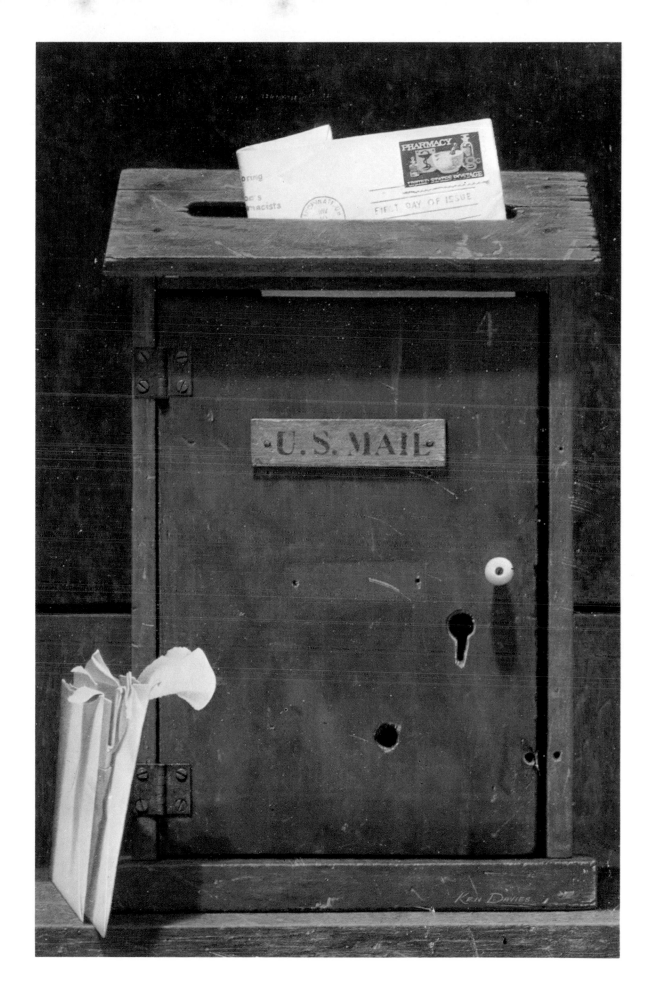

Umbrella Stand *(Left). One of my favorite pastimes is browsing through antique shops. To me they are a wonderfully rich source of paintable objects, and the excitement of discovering a subject for a new painting adds spice to the experience. The old milk can and umbrella were found on such an excursion. I had no specific plans for either of them until I arrived home and put the umbrella into the milk can for safekeeping. A few days later I glanced at the accidental arrangement and decided that the pair would be the subject for my next painting.*

Durability *(Above). Here's a situation in which a loose, suggestive background works well with a highly finished foreground object. The anvil is one of my favorite props because of its angular contour.*

Four on the Shelf. *Driving through a rural part of New York State I caught sight of these four old jugs, arranged just as they are in the painting outside an antique shop. The background is painted in a much looser style than I ordinarily use (described in Exercise 9, Monochrome Wet-Into-Wet). In this painting I was particularly gratified at having achieved a contrast between the highly finished rendering of the foreground and the more loosely handled objects in the window.*

Transparencies. *In this, one of my most colorful paintings, I utilized clear glass bottles of different tones. This painting is a particularly good example of the techniques presented in Exercise 5, Smooth Textures.*

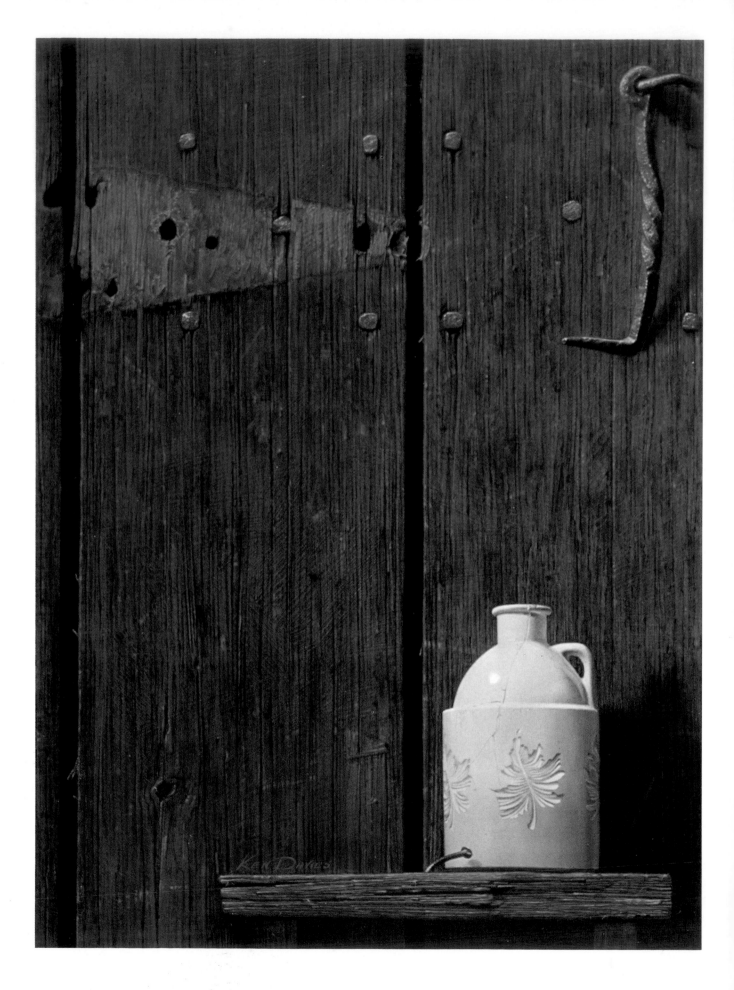

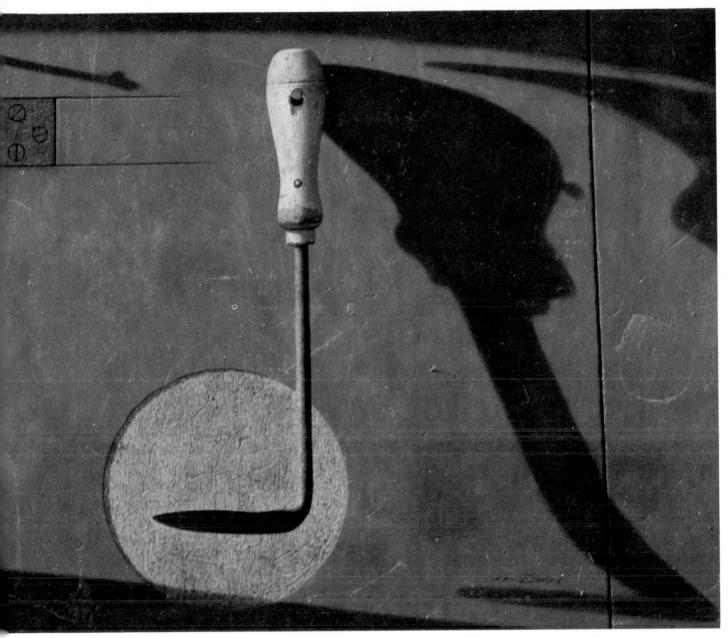

White Jug (Left). During the second half of their second year, students in the painting class at the Paier School are expected to produce what is referred to as their "major painting," the culmination of all they have learned by working through the course presented in this book. Each year I look forward to seeing the props brought in as subjects for these paintings. Occasionally I'll see ones that appeal to me for my own work and I'll negotiate with the student to either buy or borrow them. The white jug and wooden board were part of a student's setup which I borrowed for this stark, simple still life.

An Abstract Trompe (Above). This painting reveals my interest in combining ultra-realism with abstract design. The composition evolved from an old garden tool which I hung from a nail jutting through an old board. I left the board on my porch where I would be sure to see it again. As I hoped, the perfect moment occurred. It was late in the afternoon with the sun very low in the sky, and the shadow cast by the iron form onto the board fascinated me. The blue circle did not exist; I added it to enhance the abstract design.

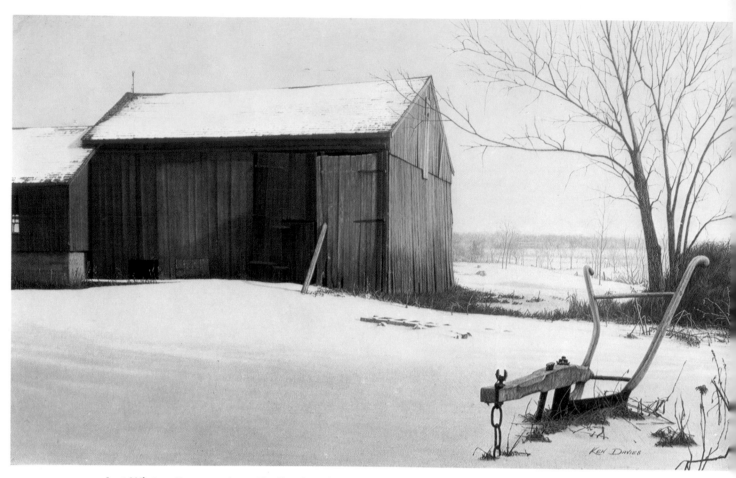

Last Winter. *I'm a true barn "buff," therefore painting old barns is a novelty that I find most enjoyable. The title of this painting suggests the fate of the barn: soon after the painting was completed the building was torn down, and now the foundation is all that remains.*

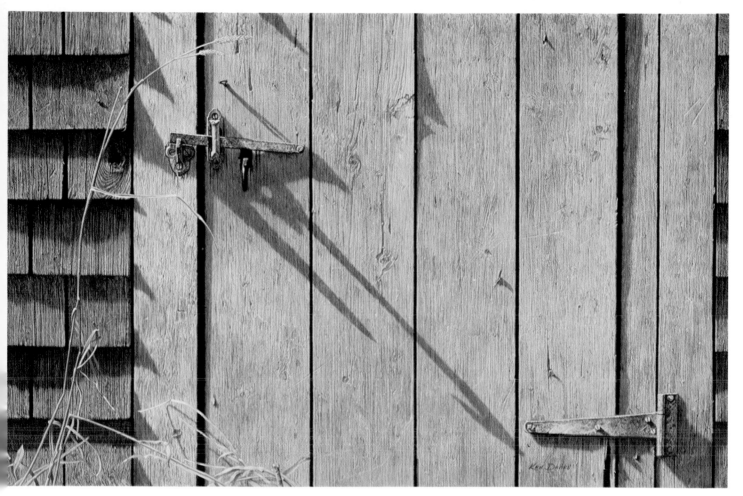

Chilmark Tool Shed. *The time I enjoy the most on Martha's Vineyard is off-season when the summer crowds have returned to the mainland. Then I can roam about unhampered by people and take in the treasures, natural and man-made, of the island. One crisp October afternoon, I happened on this scene in the yard of an old, uninhabited house in Chilmark. The perfect angle of the autumn sun on the hinge and the faded, worn wood latch was an ideal ready-made setup. I painted it exactly as I found it. And as late as the summer of 1974 it still remained, a bit faded from exposure but otherwise exactly as I recorded it.*

A Spot of Red. *I'm always happy when I'm able to combine realism with abstract composition, as in this painting. The subject, a tomato ripening on the windowsill of a house in New Hampshire, represents a memory of a visit to the summer home of a friend.*

Light and Props *(Above). The mortar and pestle are what I consider perfect subject matter, and I've used them again and again. I keep them on my living room mantle where I can glance at them every day for renewed inspiration.*

White Eggs Plus *(Right). When hung under proper lighting I can say that this is one of the most effective paintings I've done. I noticed the old bucket in a shop on Martha's Vineyard, and it was one of those occasions when an object created an instant impetus to paint—I visualized white eggs in the bucket the moment I saw it. I'm constantly foraging in antique shops for subject matter for still lifes, and usually when I find something I think I can use, I store it in my studio for months, or even years, while awaiting the proper moment to paint it.*

Genitoa and the Flying Horses Ring *(Left). In this trompe l'oeil I've used one of the Indian cards (the Indian's name is Genitoa) from my boyhood collection. Like so many other children, I coveted and occasionally won the gold ring while riding the Flying Horses carousel in Oak Bluffs, Martha's Vineyard. Even today the Flying Horses is still in use. The last time I returned there the attendants were still pushing the platform by hand to get it going as they did many years ago, carrying on an island institution—the oldest operating merry go-round in the country.*

Next to the Cupboard *(Above). Two of my favorite props are used as subjects in this still life. I'm fascinated by old cupboard doors, particularly those with decorative white knobs, and I've used them and the two props repeatedly in my paintings. The blue pattern on the white knob provides an accent that suits the color harmony of the picture.*

143

PART THREE **DEMONSTRATIONS**

Mechanical and technical skills can be quite dogmatically demonstrated and taught, and any student, providing that she or he possesses the interest and patience, can acquire those skills by working through the first parts of this book in a dedicated way. I've said very little about *composition* until now, but from this point on more emphasis will be given to this subject.

The composition or structure of a painting, I think, is a complicated, esoteric, and problematic aspect. It's possible to make a judgment of a design for yourself, but impossible to make a definitive rule for others.

There are hundeds of books on the subject of design, and they contain hundreds of different expert opinions. Established painters are constantly involved in an intellectual struggle over how to compose their work. Students who are searching for their own "right" way may find themselves in a similar predicament. What should they do? I suggest that you start with externals: (1) read and study every available book on the theory of composition and design; (2) study the paintings of the old masters; (3) take an art history course; (4) investigate books on color and color relationships; (5) visit art galleries and museums. After a time you'll find that you've absorbed some very important information. And once you've developed an awareness of how a painting is composed, you should be ready to draw on your own internal attitudes on the design of your pictures. It is then time to ask yourself, "Where do I want the center of interest? Do I even want a center of interest? What will be the color harmony or dominance of this painting? Where shall I place my lights and darks?"

In the Whitfield House *(Left). The Whitfield House, reputedly the oldest stone house in the United States, is located in Guilford, Connecticut. I found the subject for this painting while exploring the second floor: I spotted the wooden bonnet form in the bedroom and decided to use it. The painting took more than 300 hours to complete, the longest time I've ever spent on one picture.*

BREAKING THE RULES OF COMPOSITION AND DESIGN

With the experience that comes from painting on a regular basis, your concept of composition and design will mature. Decisions will come more easily and you'll begin to use instinct more often than the rule book. I found this was especially true in my own development as a painter. Now at times I'll deliberately violate one or more of the established rules. For example, in the painting *On Peases' Point Way* I deliberately placed the focal point in dead center and made the picture almost perfectly symmetrical instead of heeding the old clichés "never put the center of interest exactly in the center; never divide a painting in half; asymmetrical is more interesting than symmetrical." And the painting worked.

SUBJECT MATTER

Many of my compositions evolve as a result of my fascination with the abstract forms of some of my subjects. This was true in *Window on Dock Street.* Several years ago, while I was on one of my many subject-searching trips on Martha's Vineyard where I've spent many summers since boyhood, I stopped for a sandwich at an outdoor lunch counter on Dock Street in Edgartown. As I turned to leave the counter, I glanced at the tiny building directly across the street and saw a window. It was one of those wonderful, unexpected moments when a complete subject for a painting suddenly appears. The abstract shapes formed by the shadows on the torn window shade and the reflection in glass of the building across the street totally intrigued me. I knew I had a good subject. The window looked exactly as you see it in the painting except for the antique doll, which I added later as a point of interest.

I felt lucky to have found the spot, thinking that if I had stopped for lunch just an hour or two earlier or later I would have completely missed this particular pattern of shapes. From experience I know that I can always return to

On Pease's Point Way

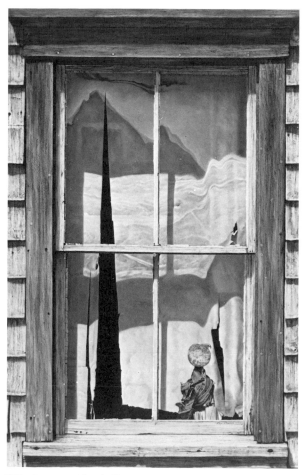

Window on Dock Street

the same place or subject again and again at different times of the day and find a totally new and unexpected thing happening there. Several of my paintings evolved as a result of an unexpected confrontation with the subject. Among them are, *A Spot of Red, An Abstract Trompe*, and *In the Whitfield House*, all illustrated in the Color Plates.

TROMPE L'OEIL, WHAT IS IT?

In the demonstrations that follow, I invite you to look over my shoulder and "tune in" to my own thinking on design and technical procedures while I lead you through the construction of several of my paintings from start to finish. The first demonstration will illustrate what I like to think of as my specialty, trompe l'oeil still life painting.

The French term *trompe l'oeil* translates literally as "fool the eye." For our purposes, let the definition be: *a still life painting in which the objects are so realistically rendered that the viewer is often tricked into believing they're real.* In a convincing trompe l'oeil, some of the objects seem to project themselves into the space between the flat plane of the picture and the eye of the viewer.

Trompe l'oeil painting dates back through the history of art to a legend of a Greek artist named Zeuxis of the Ionian school who painted a bunch of grapes so perfectly that birds swooped down to eat them. There are monumental examples of trompe l'oeil paintings that remain from the Renaissance period. During this time Veronese, among others, painted whole walls of rooms with decorations, false pillars, doorways, and windows. More recently Raphaelle Peale and my three personal favorites, John Haberle, William Michael Harnett, and J.D. Chalfant, established trompe l'oeil painting as a form of American folk art.

Although a trompe l'oeil is always a still life, a still life is not always a trompe l'oeil. In order to be a good trompe l'oeil the painting must have a depth that appears to be no more than a few inches.

The eye is fooled when a shallow depth is represented in the painting. Simply stated, when the human eye perceives a three-dimensional object from any distance, the eye muscles must make adjustments to focus on it. When the eye sees a painted object, the muscles no longer have to make those adjustments because the eye need only focus on the two-dimensional picture plane where illusion of depth is provided by perspective. Because the muscle adjustments are not as complicated as they are when viewing a three-dimensional scene, the depth of the painting is never really convincing. On the other hand, if the depth of the painting is extremely shallow, thereby minimizing the eye muscle activity, then the illusion of reality is enhanced.

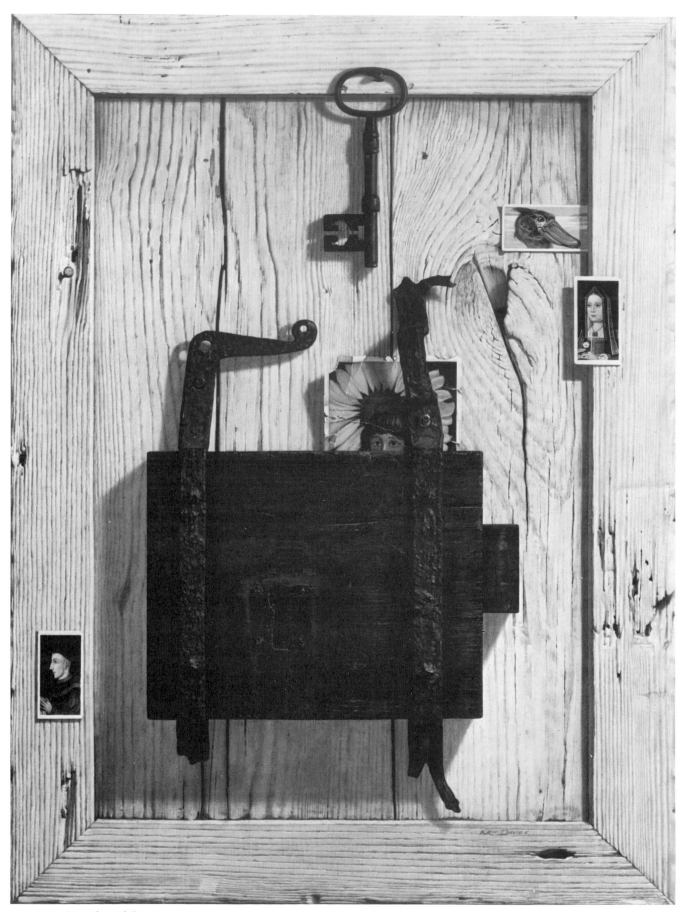

Iron, Wood, and Paper

148

DEMONSTRATION 1
FROM THE SKETCHBOOK

To exemplify my definition of trompe l'oeil painting, I've included several typical devices in the first demonstration painting, *From the Sketchbook*.

Setup. The background of the painting is a battered blue door with hinges (Figure 1) and a small white porcelain knob. The door and the picture plane are one and the same, which assures a minimum of depth in the setup: the depth from the tip of the white knob to the inside of the knothole is no more than an inch or so. Tacked to the door is a page from one of my sketchbooks. I plan compositional details, such as the shadows of the thumbtacks pushed in at different depths, the perforated edge of the paper, and the shadows on the door cast by the slightly curled and wrinkled page in order to heighten the eye-fooling effect in the finished painting. During the drawing I decide to show pencil sketches of three demonstrations from the book: the sketch for this painting itself is shown just behind and above the blackboard; the sketch for Demonstration 2, *Gray's Spoons*, shows to the left of the blackboard: and just barely visible to the right of the blackboard is the sketch for Demonstration 3, *A Gisler Mallard* (Figure 2).

The small blackboard, one of my favorite props bought many years ago in Williamsburg, Virginia, has been used in several of my paintings. I like it particularly because it gives me the opportunity to include painted chalk marks in a picture, and also because I can use a most startling and effective trompe l'oeil trick—a drop of water.

The Buffalo Bull Indian card tucked behind the page from the sketchbook is from a collection of chewing-gum cards I've saved since I was a young boy. The set was one of my prized possessions, and through the years I've used several cards from it in my trompe l'oeil paintings. One of them appears in *Genitoa and the Flying Horse's Ring*, which is reproduced in the Color Plates. The title of the painting was partly inspired by that card.

The final item I add to the setup is the small newspaper clipping (Figure 3), another favorite prop used by trompe l'oeil painters past and present. The clipping is part of an actual review of one of my exhibitions. The headline is quite clear, but the small typeface in the sketch is painted in illegible hieroglyphics. However at first glance the small typeface seems readable, and invariably the viewer moves in for a closer look only to find that the artist, tongue in cheek, has had his joke. Some painters have used the newspaper clipping device but have made the fine print totally readable—a most difficult feat. Notable among those are J.D. Chalfant and John Haberle, who are in my opinion two of the most skillful trompe l'oeil artists of all time.

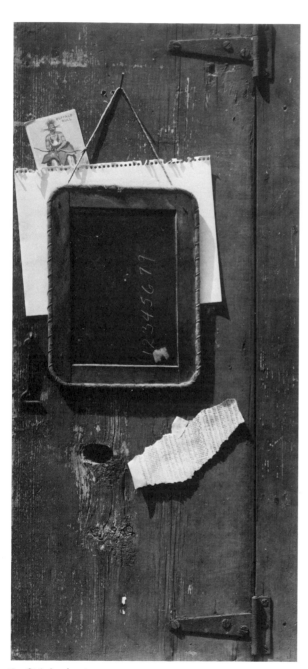

1. *Original setup*

2. *Line drawing*

3. *Drawing of newspaper clipping*

Rough Sketch. For many paintings, a small rough sketch is the only preliminary drawing I make (Figure 4). The basic thinking is worked out in roughs like this before I go on to make the finished drawing on the panel. In some cases, the little pencil-rough is almost an exact miniature of the finished painting. My drawing for *The Umbrella Stand* is an example of a rough sketch with which I'm able to visualize the end result (Figure 5).

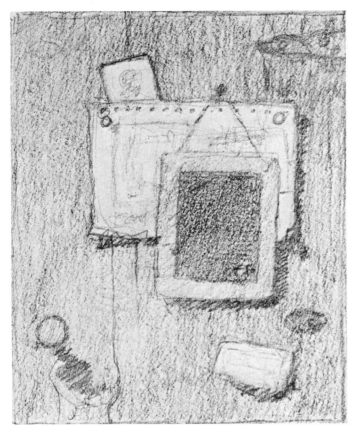

4. *Rough sketch*

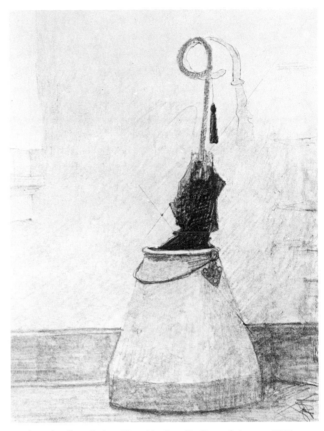

5. *Rough sketch for* The Umbrella Stand *(page 130)*

Line Drawing on Primed Panel. From the rough sketch I make a precise drawing on primed panel (Figure 6). I carefully draw the shadows in the finished line drawing. I like to use ¼" thick Masonite panels which I prime (coat) with acrylic gesso. Masonite board can be cut to the panel size you want at any lumberyard, and acrylic gesso is usually stocked by art supply stores. I apply one coat of gesso to the back of the panel and two coats to the front, using a wide, flat bristle brush. The bristle gives the gesso coat a very subtle texture, insuring against an overly smooth, slick finish. The bristle finish is also useful when developing the textures of wood or stone in a painting. Where texture is considered undesirable (in this case on the newspaper clipping and the Indian card), it can be sanded off the panel with fine sandpaper.

I take care to draw all the objects in the setup actual size. As a general rule in trompe l'oeil painting, this heightens the fool-the-eye effect. When satisfied with the drawing I spray it with a couple of coats of fixative, making sure that the whole drawing is covered.

Wash-in. I mix thin washes of pigment at the approximate values and colors I'll want them in the finished painting. I then proceed to wash in the objects and the background, brushing the thinned paint in the direction of the actual wood grain to suggest its texture. I think of the wash-in as a very valuable step. It quickly covers all of the white panel, and I can get a fairly accurate impression of the finished painting from the start.

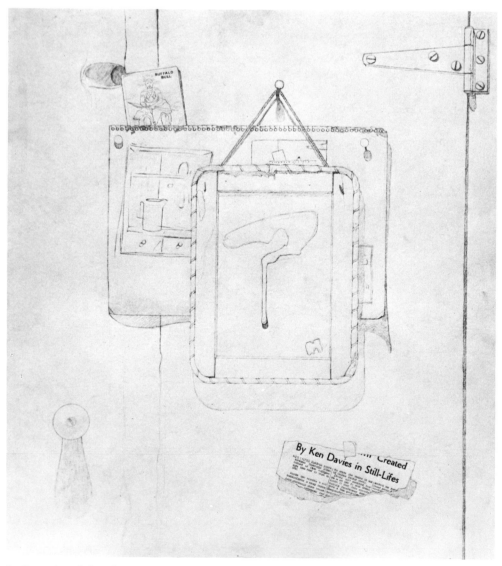

6. *Completed drawing*

Block-in and Details. The block-in is a second coat of opaque or semi-opaque paint that is applied after the wash-in is totally dry. If you've completed all the exercises, you should be quite familiar with this procedure.

In the wash-in/block-in stage in the Color Plates, the wooden door shows all three degrees of completion (wash-in, block-in, and final highlights and details). The upper left area around the knothole is finished, the middle area is blocked in with opaque color, the objects are washed in, and the lower section at the white knob and newspaper clipping is washed in and awaits a second coat.

The texture of the wood grain, created during the wash-in, barely shows through the block-in above the knob (I used some of this texture advantageously when painting the wood grain). The opaque block-in also lightens the shadows under the sketch page and the blackboard; the shadow under the white knob is still in the transparent wash-in stage and is still quite dark (Figure 7). (In the finished painting in the Color Plates the knob appears white, but it is actually several values darker to provide contrast with the highlights. Even the highlight is mixed with yellow ochre, cadmium yellow light, and white.)

I apply the paint in the wash-in and block-in just up to, yet not over, the objects. A little overlapping is acceptable, but I prefer to avoid this in order to keep the drawing intact.

Normally I'd block in the entire wood background before painting any of the texture, but to illustrate the steps involved I finish the detail on only one section of the wood before completing the block-in.

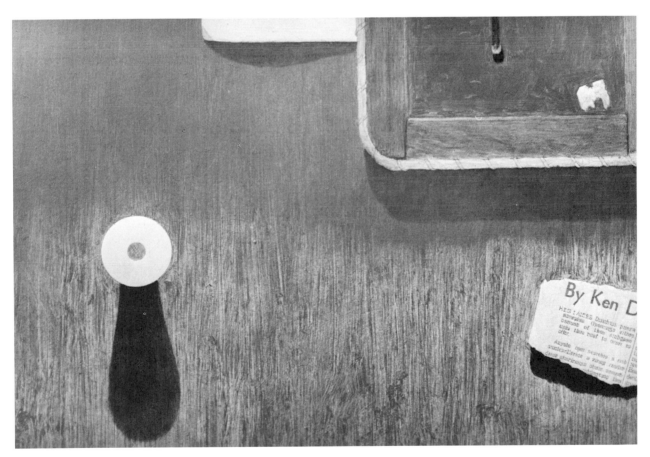

7. *Partial block-in*

Scumbling the Wood Texture. Using an old sable brush loaded with an opaque mixture of paint, I place the bristles flat against the panel (Figure 8). I dry-brush (scumble) the paint, which is slightly lighter in value than the coat beneath it. Using quick back-and-forth strokes I develop an irregular broken texture on the surface. I scumble in the shadow areas as well, making them barely discernible. This dry-brushing produces various interesting shapes.

Then, with a well-pointed sable brush, I accent the shadows and highlights of the accidental shapes produced by dry-brushing to make them look like holes, scratches, grooves, and cracks on the surface of the wood. Also, when I find an interesting shape from the original wash showing through, I make use of it for textural effects. I'd advise you to keep a piece of old, slightly battered wood around as a model to work from.

8. *Scumbling the wood detail*

Glazing the Wood Texture. After painting the texture, I let it dry thoroughly. Then I glaze the shadows as outlined in Exercise 13: (1) I wash on the glaze; (2) I daub it with a soft rag; and (3) I add one more step at this point—with an old filbert brush, I carefully dab at the edge of the finished shadow to soften it slightly. If you try this, remember that the edge of a shadow closest to the object casting it is very sharp, but the further the shadow is from the object the softer it becomes. Be sure that the shadows and the wood grain are completed before painting the objects in the setup. It's virtually impossible to glaze a shadow without running some paint over an object adjacent to the area you're glazing. This may mean repainting an already finished object; therefore, I always recommend that you paint the background first.

Before the shadows are glazed (Figure 9) you can see that the wooden door appears flat. After glazing (Figure 10), the shadows create the illusion of projecting the objects away from the wooden door and thereby begin to lend a three-dimensional effect to the picture.

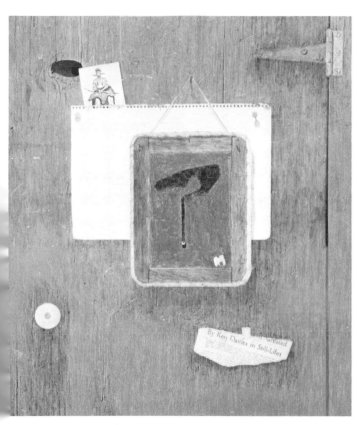

9. *Before glazing*

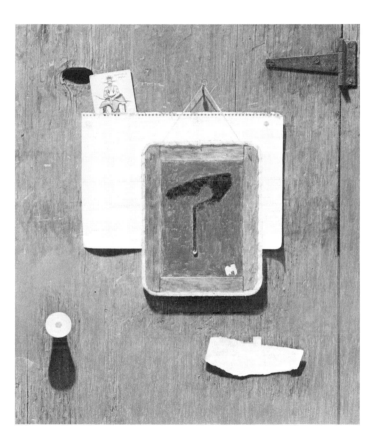

10. *After glazing*

Painting the Objects. After completing the background, the first object I tackle is the Indian card. It's painted actual size (Figure 11). My aim is to match the colors of the real card so accurately that when it's held next to the painted one it will be hard to tell which is real and which is painted. (This is a direct application of the Matching Chart assignment in Project 4.)

When the wash-in is dry (Figure 12), I block in the same area. The block-in almost completely covers the sketch, but the original pencil lines, just barely visible, still serve as a guide when it's time to add the final details (Figure 13).

After the block-in dries, I paint subtle wrinkles in the page (just as the wrinkles in the brown paper bag were drawn in Project 1). I then paint the highlights on the top perforations of the page. Just under the perforated edge I glaze the shadows down to darken them somewhat.

Next I glaze down the shadows of the thumbtacks, the right edge of the blackboard, and the strings holding it to the door. Using a pointed sable, I dry-brush the lines still visible in the pencil sketches with a mixture of raw umber, cobalt blue, and white. On completion they appear to be actual fine-penciled lines (Figure 14).

11. *Indian card (actual size)*

12. *Wash-in of sketchbook page*

13. *Block-in of sketchbook page*

14. *Sketchbook page dry-brushed*

15. *Block-in of newspaper clipping*

16. *Newspaper clipping completed*

17. *Wash-in*

18. *Block-in*

19. *Completed*

The newspaper clipping is treated in much the same way as the sketchbook page. I paint the typeface with a very small sable, using a mixture of cobalt blue, raw umber, and white in place of black (Figures 15 and 16). Had I used black paint the type would have looked too dark in value to be convincing.

After painting the knob and the hinge, which are quite routine, the last object to be painted is the blackboard. After the wash-in (Figure 17) and drying period, I block it in entirely (Figure 18). Notice that in the block-in, the surface of the blackboard is not black but is a gray mixed with cobalt blue, raw umber, and white. By varying the quantity of blue and brown I can control this mixture to get different grays. (Remember the middle-value gray you painted without black on the Value Scale in Project 4?)

The wet area and the drop of water are simply darker values of the same gray mixture. The shadow under the drop is burnt umber and ultramarine blue. As I'm painting the wet spot, I keep dabbing the real blackboard with water and studying it as the drop runs down the board. I softly blend the upper edge of the wet area since the water dries there first as it moves downward on the board. A drop of water is a very effective trompe l'oeil device, yet it's actually very easy to paint. I add the shadow, the tiny light on the lower edge of the drop, and a good, sharp pinpoint of a highlight, and presto! The drop really looks wet.

While finishing the blackboard itself (Figure 19), I add some smudges and scratches with a small, pointed sable. I then carefully copy the character of real chalk letters which I had drawn on the real blackboard by dry-brushing with a slightly worn No. 8 round sable brush. Once again, although the chalk line looks white in the painting, it's actually an off-white mixture of yellow ochre, cadmium yellow light, and white.

Varnishing. I let the painting dry for about a week or so and then coat it with retouch varnish. Retouch varnish revives the areas that have dried and "gone dead." After four to six months, when the painting has dried completely, a final coating of damar and matte varnish can be applied. I've always used a ⅔ damar, ⅓ matte mixture, but I suggest that you experiment with the proportions to get the degree of glossiness you want. The professional restorers with whom I've discussed final varnishing seem to prefer the newer synthetic varnishes.

Keeping Wet Paintings Clean. I have mentioned earlier that dust is the number one enemy of the painter. I wage a constant battle with this villain, and you will, too. It's impossible to eliminate dust completely, but perhaps these tips will help: (1) when not working on the painting, lean it with its face to the wall; (2) before each painting session, lightly lift the dust from your painting with masking tape (especially before glazing or applying retouch varnish); (3) after glazing a large area, lean the painting toward the wall, leave the room, and shut the door until the glaze is dry (the less motion there is in the room, the less dust there will be to collect on your painting); (4) don't clean, dust, or vacuum your studio while there is a wet painting in it; (5) don't acquire long-haired pets that shed. I have three cats, and although I try to keep them out of the studio, they do get in from time to time. Wet paint is the perfect magnet for loose cat hairs it seems, so I keep a pair of tweezers nearby to combat this problem.

The finished painting is reproduced in color on page 56.

Scoop and Gourd

DEMONSTRATION 2 GRAY'S SPOONS

An old spoon cabinet that belongs to a friend was the inspiration for *Gray's Spoons*. The painting doesn't quite qualify as a trompe l'oeil because the actual cabinet is between six and seven inches deep. The depth of a trompe l'oeil setup is usually shallower (see Demonstration 1). The illusion of reality is, nonetheless, quite startling in the finished work.

Composition. To suit my proposed composition for the painting I alter the appearance of the cabinet somewhat by adding drawers at the base and reducing the number of spoons which originally hung across the top shelf to three. In the finished painting in the Color Plates you can see that the white knob on the right-hand drawer is slightly larger than the one on the left. Since the drawer is slightly open, the right-hand knob is brought closer to the viewer's eye. By the rules of perspective, then, this knob must be larger to give an illusion of closeness.

For contrast and interest I add the white pitcher to the setup. Most of the final decisions on composition are made in a small rough sketch which I use as a preliminary to the line drawing. (The rough sketch for this painting is included in Figure 2 of Demonstration 1, *From the Sketchbook*.)

Line Drawing. After making the final decisions on the placement of the objects, I make a line drawing using simple one-point perspective (Figure 1). The eye level, or horizon line, is just under the shadow of the upper shelf of the cabinet, and the vanishing point (indicated by a small dot) is in the center of the cabinet. All receding lines of the sides of the cabinet and drawers converge at that dot. This is a practical application of one-point perspective, which was discussed in A Lesson in Perspective presented earlier in this book.

After sketching the outlines, I rough-shade some of the shadows in the drawing to get an early effect of light and shade areas.

Drawing the Spoons. In sketching the spoons, I use the approach to drawing symmetrical objects outlined in Project 1, Line Drawing. I draw the center line, and I outline half of the spoon. Then I trace it, flip the tracing over, and bringing the center lines into register, I transfer the tracing to the opposite half of the spoon. Finally, I add the outlines of the reflections on the handles and the bowls (Figure 2).

Drawing the Pitcher. The floral border along the top of the pitcher is a particularly important detail to retain (Figure 3). I foreshorten the tiny roses as they follow the curve of the pitcher to enhance the illusion of roundness. (This is the same principle as foreshortening a circle into an ellipse discussed in A Lesson in Perspective). Also, I use a very dark pencil line to draw the border so that the details will show through during the wash-in and block-in stages. If detail like this is lost during the painting procedure, two undesirable things happen: (1) you've wasted time drawing it in the first place, and (2) it's far more difficult to reshape the details with paint or pencil over the oil block-in.

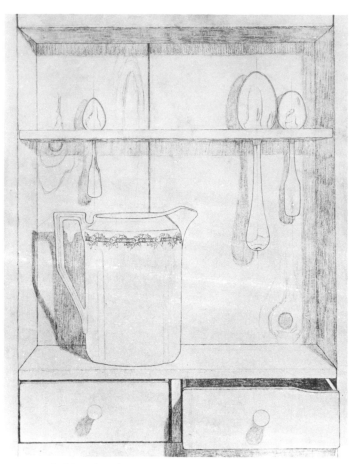

1. *Line drawing*

2. *Drawing of spoons*

3. *Foreshortening the roses*

Wash-in and Block-in. I take great care (by using adequately thinned transparent paint) not to lose the drawing in the wash-in stage. (See the wash-in stage of *Gray's Spoons* in the Color Plates.) I paint all the wood and surface textures according to the procedure outlined in Demonstration 1 under Wash-in. Then, to reproduce the wood grain of the back wall of the cabinet, I block in the back wall with a flat layer of paint (Figure 4). When the painting is completely dry, I paint each line of wood grain with a thin coat of raw umber using a pointed No. 8 sable brush. To soften the grain and make it appear to blend in with the wood surface, I dab at each line of the grain with the flat side of a No. 7 filbert.

Scumbling. After allowing the painting to dry, I scumble the entire surface with a light, opaque mixture of raw sienna, raw umber, and white (Figure 5). As much as possible I try to keep the objects intact and avoid overlapping the paint onto the spoons, knobs, and pitcher. The scumbling technique makes the wood grain more believable. A common error in beginners' work is to paint wood grain too dark, thereby giving it an artificial look.

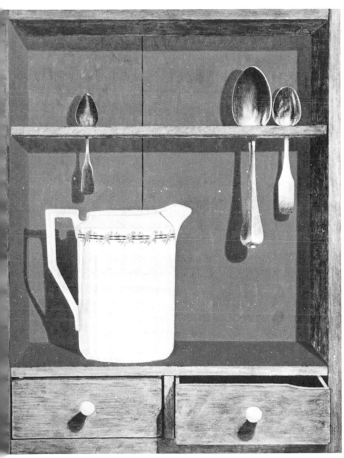

4. *Block-in of back wall of cabinet*

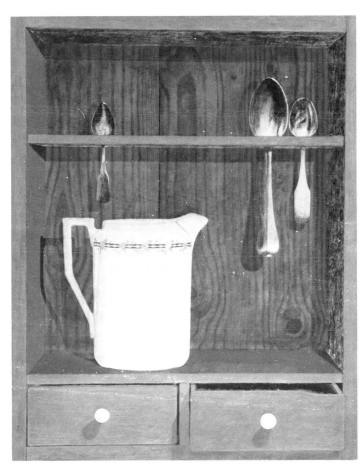

5. *Scumbling*

Final Details and Glazing. I next add all the tiny scratches and pinholes in the wood with a very small, pointed sable (No. 1). While painting the block-in I am especially careful to paint all edges of the shadows slightly softer than I eventually want them. This is important because if edges are too sharp in the block-in stage it's virtually impossible to soften them with the glaze. Yet the opposite is true; it's easy to sharpen up an edge when glazing. When all the details are thoroughly dried, I glaze the shadows. To make allowances for the reflected light I paint the inner right side and inner top of the cabinet lighter in value than the shadow on the back wall (Figure 6).

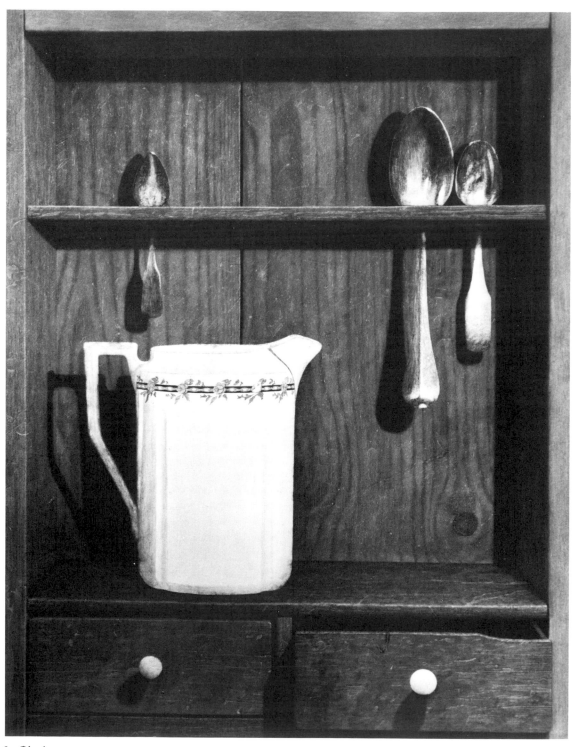

6. *Glazing*

Detailing the Spoons. In the close-up you can see that the silver spoons are completed except for the handle of the small one at the right. If you compare the details of the high-lights and reflections in the bowls of the spoons to the drawing, wash-in, and block-in, you see that they remain virtually unchanged throughout. (See Exercise 5, Painting Glass and Metal.) The highlights are very light in value and appear white (Figure 7), but you can see from the finished painting in the Color Plates that the highlights are slightly tinged with yellow ochre and cadmium yellow light. This coloring is the standard result of lighting indoor setups with incandescent light.

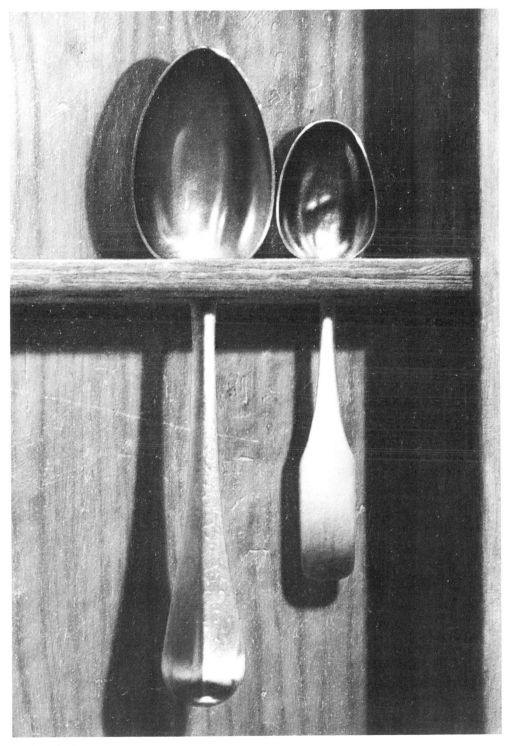

7. *Detail of spoons*

Painting the Pitcher. In the finished block-in of the white pitcher the lightest values appear to be white, but they are actually painted a darker value than white to offset the final highlights. The dark value of the wood around the pitcher further heightens its white appearance. (This principle is presented in Project 2 where the two gray squares seem to change in value when surrounded alternately by black and white borders.)

I blend the area where there is transition from light to shadow areas on the curve of the pitcher by dabbing and brushing with a filbert. Part of the detail on the floral border is almost, yet not completely, lost during this stage. This is unavoidable since I want a uniform transition from light to dark. However, it's very important for me to see the original detail through the blend. The floral decoration on the right side of the pitcher is relatively easy to see because there is little or no blending in that spot (Figure 8).

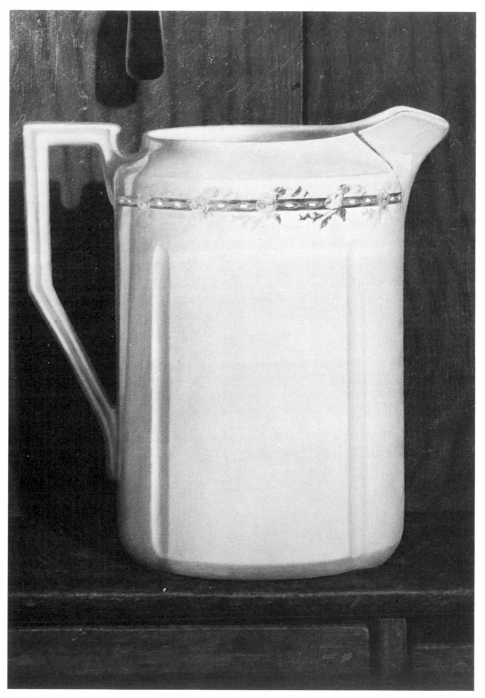

8. *Blending the pitcher*

Turning the Edges. I darken the floral border in the shadow area on the left and add final highlights, cracks, and surface details to complete the white pitcher. I glaze the shadows with a mixture of cobalt blue and raw umber. Often there is a danger that a white object against a dark background will appear to have been cut out of paper and pasted down on the painting. To avoid this I "turn the edges." By this I mean that I paint an extremely thin, dark line along the edge of the object. While the line is wet, I dab it carefully with an old, worn filbert brush, blending it very slightly into the object. I feel that this extra step makes a tremendous difference to the painting and is well worth the time and patience it takes.

The finished painting is reproduced in color on page 58.

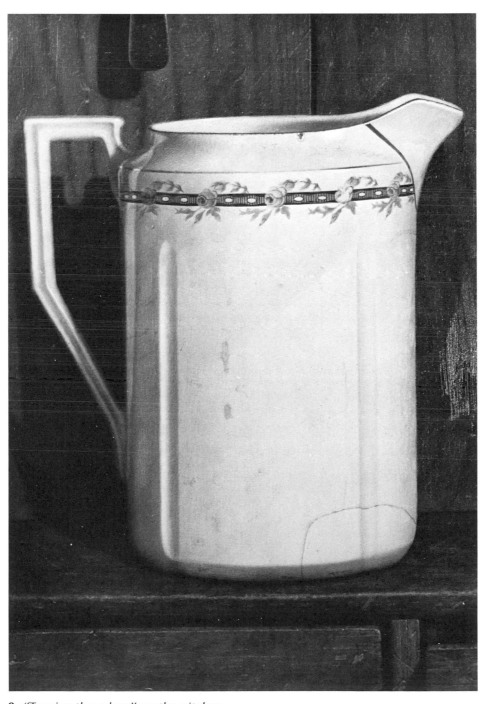

9. *"Turning the edges" on the pitcher*

Horn

DEMONSTRATION 3 **A GISLER MALLARD**

The two wooden decoys that inspired *A Gisler Mallard* were spotted in a northern Connecticut antique shop by a fellow faculty member. (The mallard decoy was named after the man who made it and in duck-hunting circles his name is well known.) I bought the pair sight unseen from my colleague's vivid description and hearty recommendation. When the two decoys arrived I saw that they were everything he had described, and I began to think about painting them right then and there.

Composition. Because the decoys are dark in value, I decide they will look best set against a light background. The old, white clapboard of the house where I live has a wonderfully mellow quality that comes from years of weathering. I've used parts of the house for details in several paintings, and this seems like another perfect opportunity to use it as a backdrop. After a few strolls around the house, I finally decide on a section of wall outside the kitchen window on which are fastened cleats and ropes used to raise and lower the awnings.

My next problem is to set the decoys up against the house just below eye level. Since I don't have a table that seems just right, I invent one by combining real and imaginary parts of an old workbench.

Then I feel that the composition will need a thin, vertical shape at the left. Rummaging around at the back of my garage, I find just the prop I want—an old scythe handle—and with this the composition is complete.

While I'm putting together the setup, I develop the rough pencil sketch (Figure 1). The finished painting is almost identical to the pencil rough.

1. *Rough sketch*

Line Drawing. I make the line drawing on a Masonite panel primed with gesso (Figure 2). As I pencil in the setup, I add the stone foundation that shows slightly at the lower left corner. Before this impromptu addition, I found I had three isolated dark shapes—the window, the decoys on the workbench (as a unit), and the scythe. The foundation relates the scythe to the decoys and table, making the darks much more interesting. Moreover, I think the composition as a whole becomes more pleasing and solid-looking.

In the drawing the eye level is at the bottom of the clapboard that passes just behind the decoy's head. In the center of the picture a black dot marks the vanishing point. Upon examining the clapboards you can see a little of the under edges of those above the horizon line. The higher they are above the horizon line the more of the under edge you can see.

In the close-up of the decoy in the forefront (Figure 3), most of the subtle shapes on the darkest part of the back were sketched to serve as a kind of map during the wash-in. In the detail of the cleat and the rope (Figure 4), the twisted fibers of the ropes are darkened so they will also be visible after the wash-in and block-in. (See the wash-in stage of *A Gisler Mallard* in the Color Plates.)

2. *Line drawing*

3. *Drawing of front decoy*

4. *Drawing of cleat and rope*

Painting the Clapboards. I paint the clapboards in various stages of completion (Figure 5). The lowest one is washed in. The next has been washed in and a first coat of rough texture created by dragging the side of an old round sable brush lengthwise over it has been added. The same brush technique was used to paint details on the wood surfaces in the first two demonstrations. But this time I add darker accents and details to the rough texture on the third clapboard, which has already received the first two steps. I paint the final and darkest accents on the topmost board. Each clapboard is painted in these four steps, and each one takes approximately three to four hours from start to finish.

When I work on this type of wood detail, I'm careful not to overdo the texture. I try to strike a happy medium by keeping details subtle. Wood surfaces should entertain the eye upon close examination, yet not distract the viewer from looking at the painting as a whole.

Painting this kind of texture can become rather monotonous, and the general tendency is to get fed up and rush through the procedures just to get them over with. Try to resist the temptation to hurry the job; it can ruin an entire painting. After a couple of hours of steadily painting details, I get that feeling myself. At that moment, I put the brush down, pick up my golf club, and hit a dozen or so balls. It doesn't necessarily help my golf score, but it does break the tension and monotony of painting.

5. *Clapboards in four stages of completion (bottom to top) wash-in to finish*

Painting the Scythe and Rope. I wash in part of the scythe handle and the rope attached to the cleat with thinned paint (Figure 6). The texture created by the wash-in on the scythe handle will be utilized in painting the detail of its grain.

The close-up of the rope next to the window shows it in all three stages of completion (Figure 7). The uppermost part of the rope is finished, the middle part, which is wound around the cleat, is blocked in, and the lowest part is washed in.

6. *Wash-in of scythe handle, rope, and cleat*

7. *Rope in three stages of completion (bottom to top) wash-in, block-in, and finish*

Part of the workbench is washed in, and its brushstrokes indicate the direction of the wood grain even at this preliminary stage (Figure 8). It will next be blocked in and glazed and scumbled as part of the detailing step.

Painting the Decoys and Workbench. The wash-in of the decoys has been completed; the block-in and detailing of the workbench are almost finished (Figure 9). The top of the workbench is made up of horizontal, elongated shapes. These shapes are important because they flatten the top surface and make it recede from the viewer.

I block in the decoys (Figure 10) and glaze down the shadow under the edge of the workbench to give it a three-dimensional look. The decoys, although now blocked in, are hardly changed from the wash-in stage.

The close-up of the mallard decoy, the central object of the painting (Figure 11), has been completed by what I call *selective rendering*. By that I mean I don't try to duplicate each and every crack and groove on its surface. Instead, I take advantage of what are, to my way of thinking, the most attractive details. I copy these quite faithfully and disregard the others. Occasionally I replace the unused details with my own invented shapes suggested by the wash-in. Which shapes to retain and which to discard are a matter of personal taste, and I believe that experience helps in making the best choices.

The finished painting is reproduced in color on page 60.

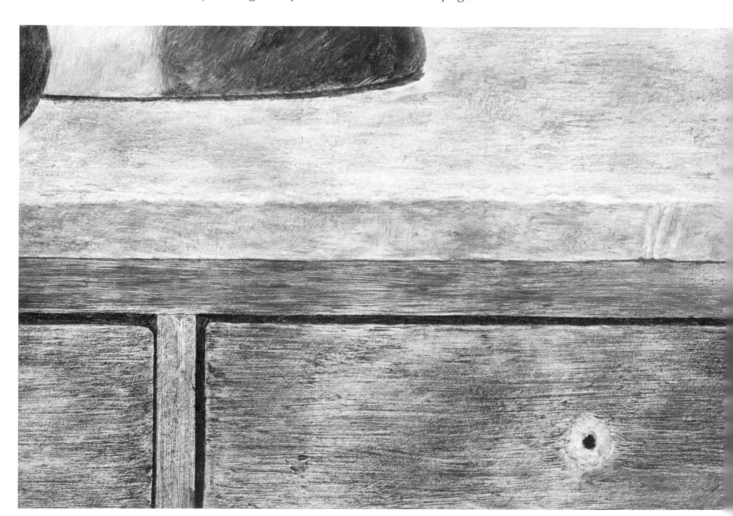

8. *Wash-in of workbench*

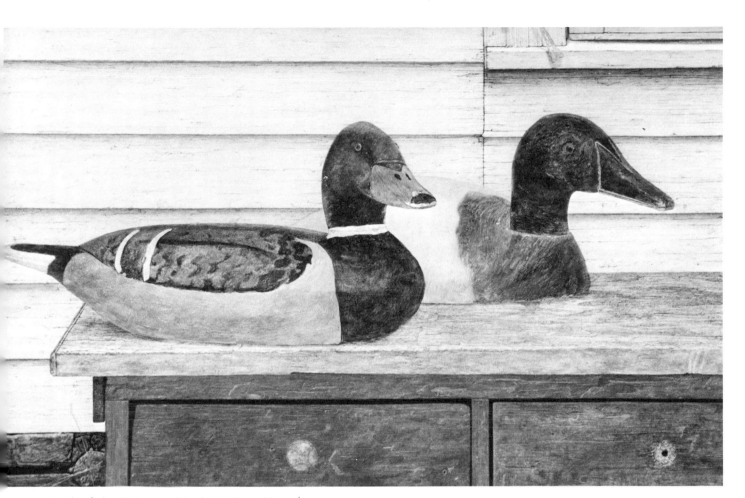

9. *Wash-in of decoys; block-in of workbench*

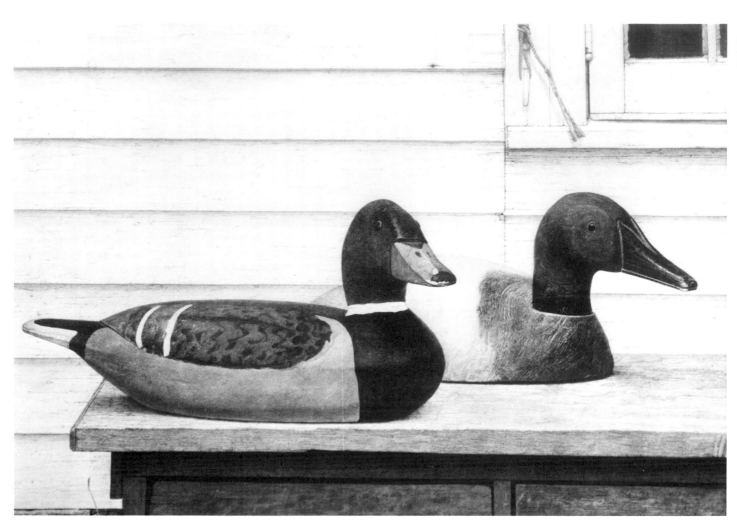

10. *Block-in of decoys; workbench shadow area glazed*

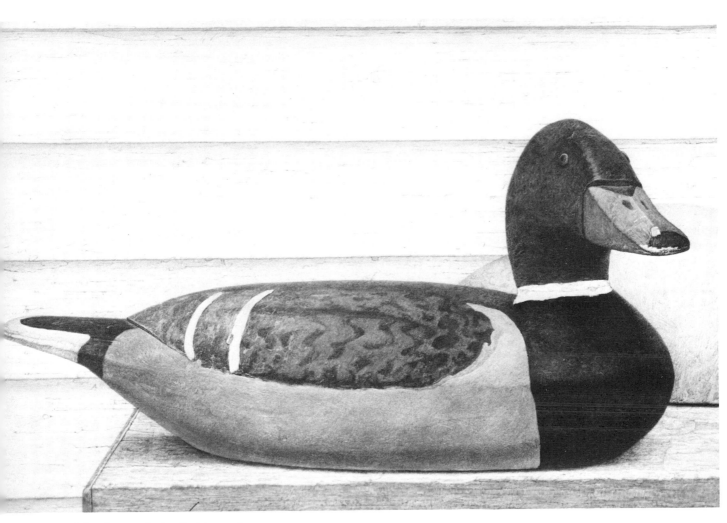

11. *"Selective rendering" of front decoy*

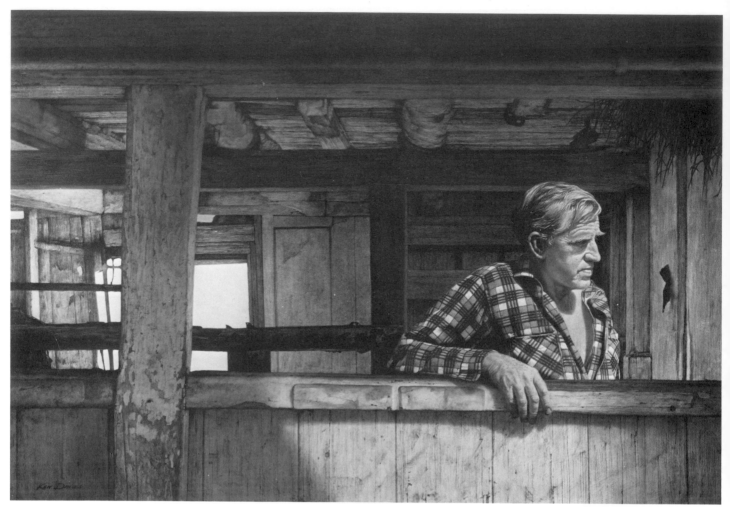

Fred

DEMONSTRATION 4 ON 139 NEAR 80

You may wonder why I include a painting of a barn in a book devoted totally to still lifes. The reason is that I consider the subject of this painting a still life. I don't believe there's a great difference between using the wooden wall of a barn as the backdrop for a trompe l'oeil still life and painting the entire barn in its own setting. Each entity can be part of a still life—the barn building, the tree, the pump, and the logs can be considered separate setups within the whole. There is no formal decree disputing my claim that a still life does not have to be restricted to the area of a tabletop. So if you enjoy painting buildings, barns, stone walls, or fences, call them landscapes or still lifes, but go ahead and paint them!

My own reason for painting barns stems from a long-standing affection for typical New England barn buildings. As subjects for paintings, I consider them ideal. Their shapes, colors, and sizes are limitless. Decidedly rich in source material, their aged wood exteriors are studded with shingles, latches, and hinges, while inside they are treasure chests bursting with irresistible trappings. It's not at all unusual for me to find subjects for a dozen or more paintings in a single barn.

I remember the sheer pleasure with which I explored the interior of a deserted barn one day and found an abstract pattern of lights and darks set off by wood beams glowing with age, their surfaces rich in detail. The scene truly took my breath away, and I used it soon after as the setting for the painting entitled *Fred*. The interior was recorded exactly as I saw it; not one detail was changed. Yet I felt that a human figure was needed for enlivenment. Soon after, I persuaded Fred, a friend for many years, to pose for me, and it was one of the the very rare instances when I've used a human figure in a painting.

I came upon the barn that inspired the painting in this demonstration accidentally while driving on Route 139 near Route 80 in North Branford, Connecticut, four years ago. It instantly caught my attention but didn't stir enough excitement to warrant a stop to investigate further. About five months later, just after a snowfall, I drove along the route again, and this time the sight of the barn dusted with snow set off a reflex. Blindly ignoring the road conditions, I jammed on my brakes to take a better look. The shape of the snow on the roof and the wood siding of the barn attracted me. The contours of the sloping eaves set the wheels in motion, and I was impatient to paint the barn still life.

Composition. Using the barn and the large tree as focal points, I begin to develop the composition. The barn, I think, will be placed in the upper right corner of the panel, fronted by a broad expanse of snow. I rough in the main shapes of the foreground and middle ground with charcoal pencil. I'm mainly interested in the major shapes rather than what they will contain. And when their places are established, I stop work to search for the appropriate coordinates to fill the voids and create perspective. I find most of what I need in my yard. For instance, the weeds shown poking through the snow were the result of my lack of enthusiasm with the lawn mower the previous fall, and the logs were the result of a burst of enthusiasm with the saw the previous day. The composition becomes whole with the addition of an old pump and a Connecticut snowfall.

Line Drawing. I make the line drawing directly on Masonite panel primed with gesso (Figure 1). The emphasized lines drawn on the silo represent the deepest cracks and the changes of color on the vertical slats. I sketch in only the largest branches of the trees; I'll add the smaller ones directly with a brush in the final step. In keeping with my usual painting procedure, the branches and weeds are drawn heavily so they won't be lost under the wash-in and block-in. I shade the rocky outcropping at the left of the barn to divide and clarify its different faces and prevent a jumble of lines from spoiling the whole shape.

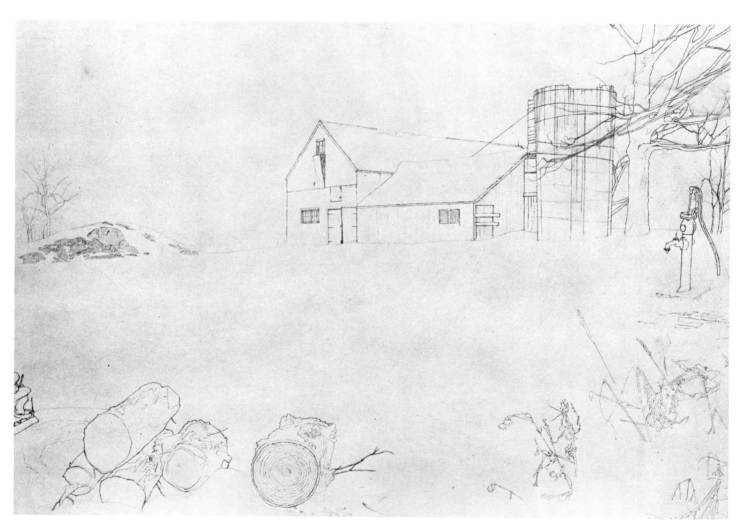

1. *Line drawing*

Wash-in. I reverse procedure and wash in the barn before painting the sky. (See the wash-in stage of *On 139 Near 80* in the Color Plates. Although I usually recommend painting backgrounds first, in this instance I want to key the value of the sky with the barn and snow. The sky, I feel, has to be darker than the snow on the roof, but at the same time light enough to offset the superimposed patterns of the body of the barn and the tree.

While the silo is still wet, I scratch out the thin, small branches of the tree with an old, stiff filbert brush. Although I plan to include puffy cumulus clouds, I wash in the entire sky area (with the exception of the slightly oblique cloud line running from the upper left edge to the barn) with a relatively flat, even color to establish its value. The oblique line suits the composition. It simply feels right and I'm instinctively comfortable including it. I rough-sketch the shapes of the clouds after the barn is dry (Figure 2).

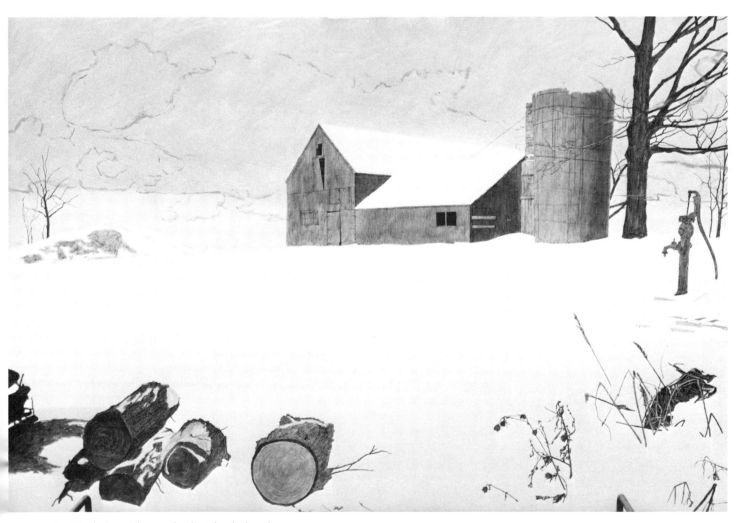

2. *Wash-in with rough-sketched clouds*

Painting the Background. The second coat of paint on the sky slightly overlaps the trees and parts of the barn (Figure 3), yet I take great care not to lose the drawing. At this critical point I run into unexpected trouble. Ideally, I prefer to be in complete control of a painting from beginning to end, to know exactly which effects I want and how to achieve them. But this time proves to be a bit different. It's late afternoon when I finish blocking in the sky, and just afterward I quit for the day. Upon resuming work the next morning I take a fresh look at the painting in progress, and it's immediately obvious that the clouds are all wrong for the picture. I was evidently carried away with their shapes, but now they look busy, with too much contrast, and they detract from the painting. I wanted the sky to be interesting, yet subtle, a backdrop for the barn rather than an aggressive passage. I correct the problem by painting a semi-opaque coat of light-value gray over the entire sky. After the paint dries, I can just barely see the cloud shapes through it (Figure 4). Remembering the mistake I made, I block in new cloud shapes to make them less overpowering in value and contrast.

The most interesting part of the sky is the open space to the left of the barn. Behind the tree the sky becomes very simple: almost flat. The corrected sky and an added stand of distant trees complete the background (Figure 5). At this point I block in the snow with a flat off-white.

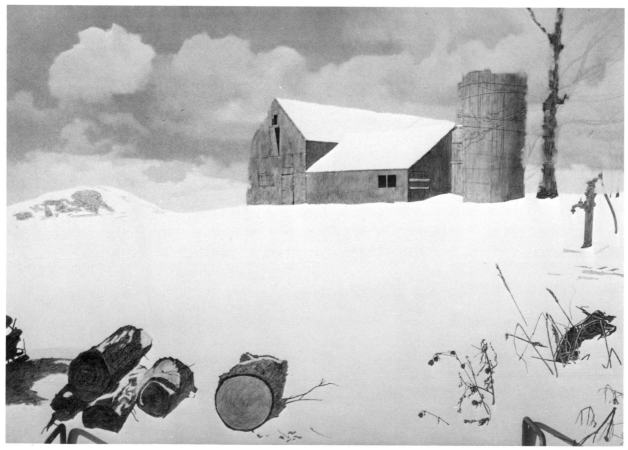

3. *First cloud block-in*

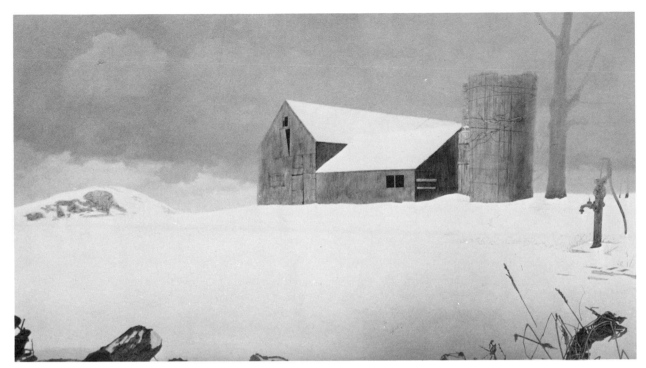

4. *Clouds corrected*

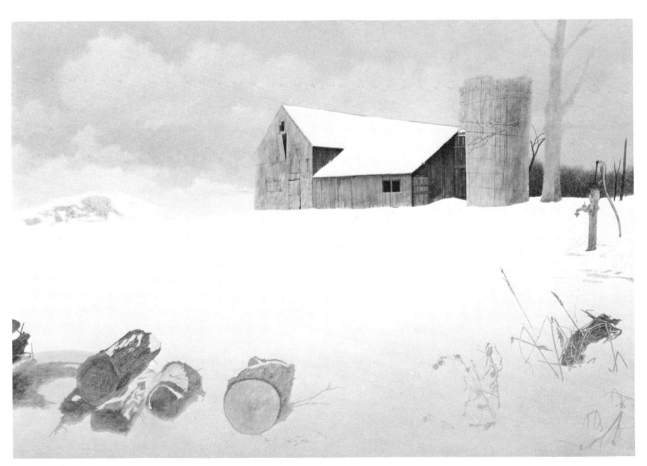

5. *Completed sky and block-in of snow*

Painting the Barn. In the close-up of the barn (Figure 6) the finished center section is a bit duller and grayer than the gaudy red color I applied during the wash-in (see the wash-in stage of *On 139 Near 80* in the Color Plates). To tone down the color of the first coat, I lightly dry-brush it with a coat of burnt umber and cobalt blue. While this second coat is still wet, I dry-brush light values of cerulean blue and raw sienna into it using vertical strokes to describe individual boards. Methodically, I apply the colors in combination and separately by turns over the surface. The layered colors slowly begin to resemble the aged barn siding.

After a drying period, I paint dark cracks and light accents on the siding of the barn. My aim is to present detail as it would be seen at a distance rather than painting each board in the fine detail reserved for objects at close range.

I finish the remainder of the barn body (Figure 7) and block in the silo. Through the paint I can just barely see the tree branches I've scratched out of the wash-in. I paint them with opaque color using a pointed sable brush.

Painting the minute branches of the trees is a complicated job, and by comparison the water pump is easy going, taking only a few hours to paint (Figure 8).

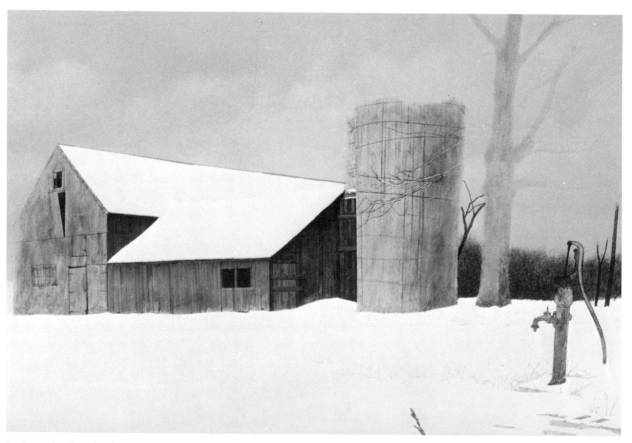

6. *Barn dry-brushed*

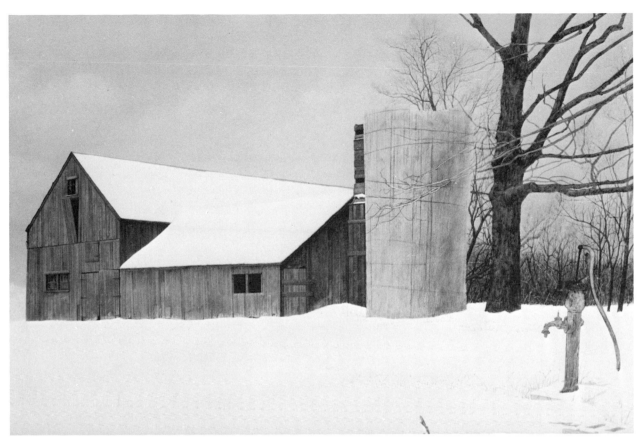

7. *Barn completed; silo blocked in*

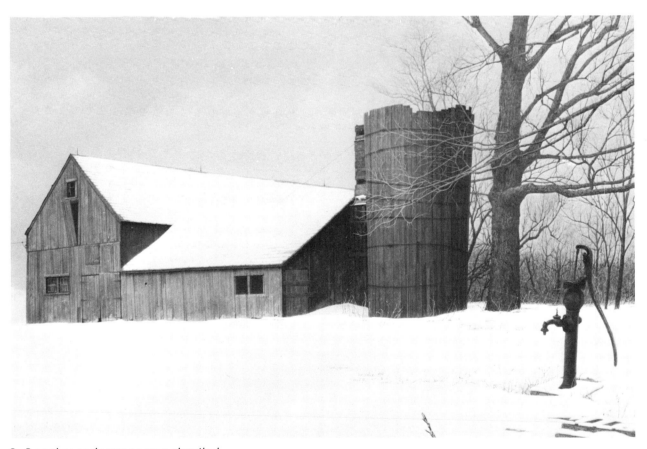

8. *Branches and water pump detailed*

Painting the Foreground. I glaze down the large shadow across the foreground with my favorite color mixture—cobalt blue, raw umber, and white. The glazed shadow painted across the snow in the foreground lightens the value of the logs (Figure 9). My reason for glazing over the logs rather than around them is to coordinate the value and color of the snow lying on their tops to the snow on the ground.

I darken areas of the logs on the left and block in the final coat. The remaining logs will be painted similarly.

To complete the weeds in the foreground, I simply darken them with opaque paint—an easy matter since they are still visible through the wash-in, block-in, and glaze. (See the completed painting in the Color Plates.)

The overhead wire leading from the barn off to the left is an afterthought. The curve of the wire is a challenge to paint without a drawing beneath to guide the brush. My solution is to draw the precise curve I visualize on a thin piece of cardboard and cut the cardboard at that line with a mat knife to make a template. I place the guide on the painting and follow it very lightly with a sharp pencil. It's then a simple matter to paint the wire with a small, pointed sable brush keeping my wrist steady with a mahlstick.

The finished painting is reproduced in color on page 62.

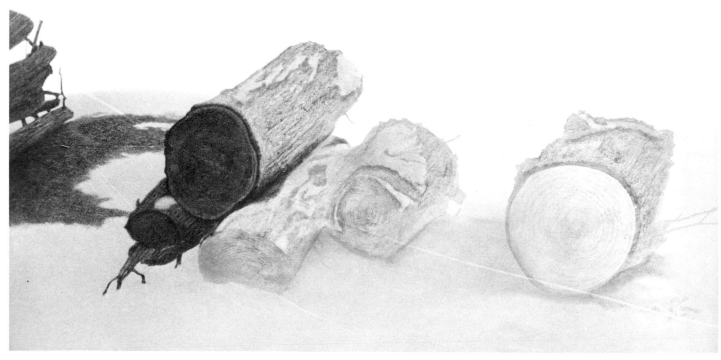

9. *Foreground and logs glazed*

LIST OF PLATES

COLOR

page

*Information on signed, limited editions of the color reproductions
of Ken Davies paintings available from: Box 902, Madison, Conn. 06443*

CREDITS

Photographers: E. Irving Blomstrann

Eugene Brenwasser

Richard Chamberlain

Geoffrey Clements

Helga Studios

Monroe Vaughn

Student Work: Lynne Hudak Project 2: Assignment 1, Figure 4

Ric La Terra Project 2: Assignment 2

Roger Woronecki Project 2: Assignment 3

Jim Laurier Project 3

Mark Keigwin Value Scale, Matching Chart, and
Color Exercises 1,2,4,6,10,12,13

Michael Mariano Color Exercises 3,5,7,8,9,11

GLOSSARY

Analogous colors. Colors adjacent to each other on the color wheel; colors of the same family which have the same base.

Binder. A material which holds together particles of pigment in a continuous film.

Blending. Applying color gradations to the painting surface to gradually merge areas of different value.

Chroma. The degree of intensity or brilliance of a color.

Color temperature. The warm or cool quality of a color; for example, Prussian blue is a cool color and cadimum red is a hot color.

Complementary colors. Colors placed directly opposite each other on the color wheel: orange and blue, red and green, yellow and violet.

Composition. The structure of a picture made by the artist that coordinates shapes, values, and colors.

Crosshatching. Shading a drawing by making two sets of parallel lines that cross each other.

Direct painting. Laying down paint on the painting surface without underpainting (wash-in).

Dry-brushing. Applying a layer of opaque pigment with a semi-dry brush to get a rough or broken effect.

Feathering. A method of blending with a brush by using quick, light strokes to pull one color into another.

Fixative. A chemical lacquer that is sprayed on a drawing to prevent the lines from smudging.

Genre painting. A painting in which the artist depicts everyday objects realistically.

Gesso. A white liquid plaster or acrylic mixture that is applied to a surface in preparation for painting.

Glazing. Brushing a dark, transparent layer of paint over a lighter layer. This allows the undercoat to show through.

Graying down. Reducing the strength of a color by mixing it or glazing it with its complement, thereby neutralizing it.

Highlight. The point of greatest light intensity on a represented form.

Line. The edge of a shape that describes its boundary or form.

Matte. A dull finish.

Medium. A substance added to pigment to make it more fluid; materials used for artistic expressions, i.e., oil paint, watercolor.

Monochrome. A color scheme in which a single color of various shades is used.

Opaque. Nontransparent.

Palette. An oblong board or pad on which an artist mixes colors; sometimes used to mean the range of colors used by an artist.

Pigment. A powdered coloring matter mixed with a binder, linseed oil, to make oil paints; informally, the whole paint substance itself.

Primary colors. Red, yellow, and blue.

Priming. Preparing the painting surface with gesso or paint.

Scumbling. Brushing opaque color over an already painted and dried surface, sometimes allowing part of the undercoat to show through.

Stump (tortillon). A narrow, tightly packed roll of paper, pointed at one end, used for rubbing and/or blending drawings.

Stippling. Painting or drawing small dots rather than lines to create a form, shadow, or highlight.

Taboret. A low table with drawers and cabinet to hold drawing and painting supplies.

Trompe l'oeil. A French term meaning "fool the eye"; a painting rendered so realistically that the viewer is temporarily convinced the objects are real.

Value. The relative lightness or darkness of a color.

Wash-in. A transparent layer of thinned paint; usually a first coat.

INDEX

Edited by Sarah Bodine
Designed by Bob Fillie
Set in 11 point Zenith by Publishers Graphics, Inc.
Printed by Parish Press, Inc., New York
Bound by A. Horowitz and Son, New York